IMAGES
of America

JUNGLELAND

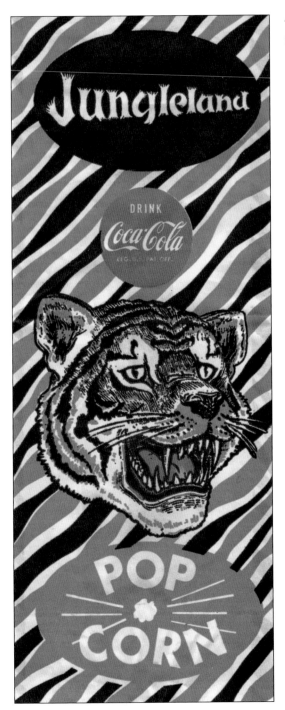

This Jungleland popcorn bag dates from the 1960s. (Author's collection.)

ON THE COVER: Capt. Frank Phillips performs his head-in-the-elephant's-mouth trick in 1931. This antic led to a 1931 appearance in a newsreel film that was shown in theaters throughout the country. (Courtesy of Richard and Tuve Kittel.)

IMAGES
of America

JUNGLELAND

Jeffrey Wayne Maulhardt

ARCADIA
PUBLISHING

Published by Arcadia Publishing
Charleston, South Carolina

Printed in the United States of America

Library of Congress Control Number: 2010940865

For all general information, please contact Arcadia Publishing:
Telephone 843-853-2070
Fax 843-853-0044
E-mail sales@arcadiapublishing.com
For customer service and orders:
Toll-Free 1-888-313-2665

Visit us on the Internet at www.arcadiapublishing.com

This book is dedicated to the historians, collectors, and
storytellers for the legacy of Jungleland, including Pat Allen,
Jeanette Berard, Robin Kabat Dickson, Alma Goebel Heil,
Sandy Hildebrand, Richard Kittel, and Miriam Sprankling.

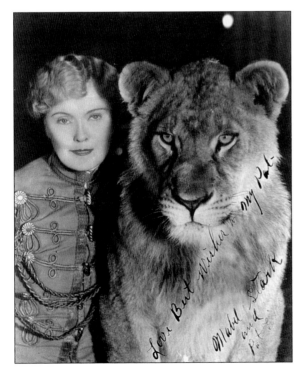

Mabel Stark is depicted with her lion
during the 1930s. Stark most enjoyed
working with Bengal tigers, but she
loved all big cats. (Author's collection.)

CONTENTS

ACKNOWLEDGMENTS

I want to thank several people who helped put this book together. First, I want to thank Sandy Hildebrand and Miriam Sprankling from the Stagecoach Inn for allowing me to scan their archives and gather information from their Jungleland exhibit.

Next, a sincere thank-you goes to Jeanette Berard from Special Collections of the Thousand Oaks Library. Jeanette helped from the beginning of this project to deadline time, when she made it possible to complete the last-minute tasks.

Richard Kittel is another major contributor to this volume. Richard was fortunate enough to meet Capt. Frank Phillips and his wife, Siva, and they entrusted him with Frank's archives of pictures and newspaper clippings. Richard, in turn, gave me the chance to scan images from this collection. Without those photographs, this book would be incomplete.

Also, coming through for the project in the waning moments was the input of Robin Kabat Dickson. Robin's images helped shape this book into a better representation of the place she once called home and the people who lived there. As Robin says, "It was a special place to grow up"—both for her and for us.

Finally, I am indebted to all the websites and blogs about Jungleland and the circus world that helped me find a direction in completing the story of Jungleland. A lot of misinformation about Jungleland has been accepted as fact over the years, and my goal was to sift through the stories and get to the truth behind them.

Many stories and pictures did not make it into this publication because, at the time, they were not available. However, the hope behind this book is not only to refresh memories and tell the story as is but also that more pictures and stories will come forth—because with almost every story, there is always another chapter.

The images that appear without credit are from the author's collection.

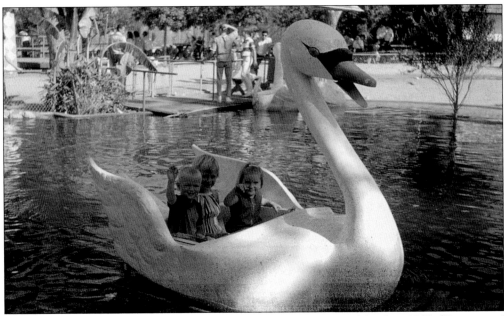

Karen, Jayne, and Brian Robertson navigate the swan boat at Jungleland in 1965. (Courtesy of Conejo Through the Lens, Thousand Oaks Library.)

INTRODUCTION

The story of Jungleland begins with the arrival of Louis Goebel to Thousand Oaks, California. Goebel was born in New York in 1896. He was the son of a butcher. By 1919, young Goebel decided to venture to the West Coast, ending up at Gay's Lion Farm in Westlake Park (now MacArthur Park), where he used his meat-cutting skills to land a job. When Charles Gay moved his lions to El Monte, California, Goebel sought employment at the Universal Studios zoo, which was run by one of the owners of Universal, Carl Laemmle. By 1926, Laemmle announced he was selling his zoo animals. Goebel, who by that time was earning extra cash by working with the animals for the film industry, decided to invest in the six lions, which he could rent back to the studios.

Finding a place to keep his lions led Goebel north, first to Agoura, which turned him down, and then to a new community that was not even on the map, Thousand Oaks. When Goebel went to the Ventura County office to acquire a permit to build a home and a place to house his animals, no one at the supervisor's office knew where he was talking about. Finally, Ventura sheriff Bob Clark asked him to interpret where this rural place might be, and Goebel replied, "You can reach it by driving up a crooked road (now Conejo Grade) to the top of the hill." This is where Louis Goebel made a home for thousands of animals that starred in hundreds of movies during the next 40 years.

Goebel bought five lots off old Ventura Boulevard (now Thousand Oaks Boulevard) for $10 each and built cages for his six lions, which were named Andy, Bill, Little Cesar, Min, Momma, and Poppa.

On most days, he would leash his lions to an oak tree, and, inevitably, passing motorists would stop to look. If Goebel was around, he would answer questions. This led to his next plan. In addition to renting out his lions, he decided to open his site to the public and create a roadside attraction.

By 1929, he added more exotic and wild animals, creating Goebel's Lion Farm. To make sure his lions were used for *Tarzan, the Ape Man* (1932), the original Johnny Weissmuller version for MGM, Goebel camped out at the film site near Lake Sherwood in eastern Ventura County. Such dedication landed his lions their parts. After adding more wild animals to his menagerie, Goebel changed the park's name to Goebel's Wild Animal Farm.

Goebel's first big-name animal to be featured at the park was Leo the Lion. Leo's real name was Slats. He was used as the MGM lion from 1924 to 1928. In 1928, he went on a world tour with trainer Capt. Frank Phillips, who would eventually find his own way to what became Jungleland. In 1934, Goebel made a request to use the phrase, "Home of the MGM Leo the lion," on ashtrays to sell at the park. Slats died in 1938, though some accounts give a different date. Jackie the lion, who replaced Slats as the MGM logo from 1928 to 1956, and subsequent "Leos" also resided at Jungleland over the years.

Joining Goebel at his lion farm was Kathleen "Kathy" Parks. Parks and her parents moved to Thousand Oaks in 1925. She began having trouble milking the cows not long after. It seemed that every morning when she attempted to draw the milk, Goebel's lions would let out mighty roars, intimidating the cows and inhibiting their milk production. After a few days of this inconvenience, Parks approached Goebel. But instead of complaints, the two entertained a mutual attraction, leading to marriage.

By 1946, Goebel sold the park to Trader Horne and Billy Richards. Both men were veterans of the zoo community. Horne was an animal importer from St. Louis, Missouri. Richards was a former manager of the Al G. Barnes Trained Wild Animal Circus, as well as the manager and owner of the Selig Zoo in Los Angeles. Planning to expand the park, they renamed it the World Jungle Compound. Horne brought in exotic animals from his St. Louis zoo, and Richards brought many of his trainers and animal actors from his old zoo and circus. Having worked in over 600 films, Melvin Koontz was one of the more famous trainers of the bunch.

Soon to follow was Capt. Frank Phillips, who had toured with Leo the Lion in 1928 and was also very active in the motion picture industry. Already stationed at the park was the premier lady big-cat tamer, Mabel Stark. Stark's tiger act started out in the 1920s and included an erotic wrestling act with her tiger, Rajah, at Madison Square Garden in New York. She moved to Thousand Oaks in 1938 and became a mainstay up until the final months of the park.

Horne and Richards also added more circus acts. Many of the leading circus companies would take part in the performances while wintering at the animal compound. The number of animals grew to the point that the compound advertised more trained wild animals than the three largest circuses combined.

The name Jungleland came from the third set of owners, James Ruman and Sid Rogell, in 1955. While both men worked for 20th Century Fox, the purchase was strictly their investment, not the studio's. Working with manager Jimmy Woods, they planned a world-class attraction intended to rival the newly opened and popular Disneyland located 62 miles southeast in Anaheim. Using data obtained from the Stanford Research Institute, the new "Disneyland with Live Animals" was to include a tramway to accommodate patrons to areas of the park, including a safari area where animals could be viewed in their natural habitats.

The five-year plan to upgrade Jungleland failed. By 1961, the property and animals reverted back to Goebel. He and his new partners, Heinz and Lutz Ruhe, planned a new Jungleland. But after spending money that did not achieve the desired results, the partnership was dissolved.

Roy Kabat took over as park manager. By 1964, Kabat and Thurston "Tex" Scarborough became quarter partners each. The next year, they took on 100 percent ownership. The new partners looked like they were on the right track. Kabat brought in Chucko the Clown for birthday parties. Chucko was well known for his days on ABC and Los Angeles's channel 11, where he had his own show for almost a decade. They also spent $90,000 for the Sky Glide tram. The petting zoo was expanded. Another priority was leasing more animals to the movies, including for *Doctor Doolittle* (1967). Roy Kabat took control of the animals for the movie.

However, the valiant efforts were for naught. Too much money was required to upgrade the park to the level of pristine modern amusement parks, such as Disneyland, Universal Studios, and Knott's Berry Farm. Plus, a series of tragedies occurred, the first in 1966 when Tex Scarborough was attacked by a lion, resulting in a partial amputation.

A few months later, Zoltan Hargitay, Jayne Mansfield's son, was mauled by a tiger and almost lost his life. By May 1969, it was plain to the owners that they would have to file for bankruptcy, returning the park and property to Goebel. On October 8, 1969, a public auction was held to sell off the 1,800 animals, all the equipment, and anything else that was not bolted down.

The legacy of Jungleland in all its incarnations lives on. Most people have fond memories of it, and some are amazed by its numerous connections to the film industry. Many famous animals resided at the park, including several MGM Leo the Lions (known as Jackie I, II, and III); Tamba and Peggy, the chimpanzees from the Tarzan and Bonzo movies; elephants Bimbo from the *Circus Boy* television show and Big Emma from *Elephant Walk* (1954); Satan the tiger; and hundreds of other film and television animals. Their trainers—Mabel Stark, Capt. Frank Phillips, Melvin Koontz, Louis Roth, George Emerson, Henry Tyndall, Wally Ross, Roy Kabat, and others—also provided important connections to the movies.

One

THE PARK

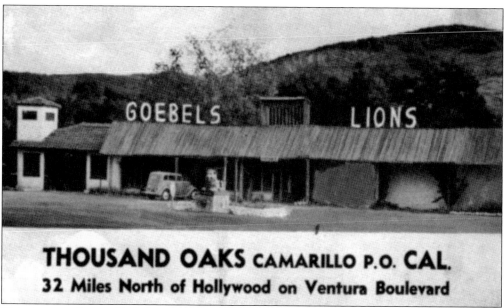

This image is from a 1930s brochure. It features the earliest roadside building used by Goebel's Wild Animal Farm. By that time, Goebel's was the home of MGM's Leo the Lion, the world's most famous motion picture trademark, and 101 other wild animals. Louis Goebel opened his doors to the public in 1929 after realizing his lions caused automobiles traveling along the road to slow down and take in the unusual scenery.

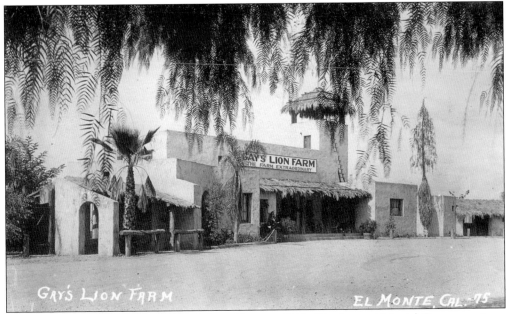

Louis Goebel began working at Gay's Lion Farm in 1919. Charles and Muriel Gay were circus performers, and Charles trained animals for the motion pictures. Gay's Lion Farm relocated to a five-acre plot of un-zoned property in El Monte. At one point, the amusement park housed 200 adult male lions. Among the animals Charles trained were several of the MGM lions, including Slats, who served as the logo of MGM films from 1924 to 1928.

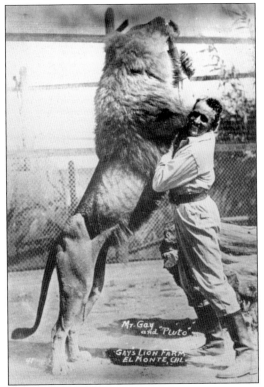

Charles Gay would use a whip and a gun to perform several stunts with the lions. One of the acts at the park was to stuff mannequins with meat so that the lions appeared to be attacking the human-looking stiffs. Gay's Lion Farm used horse meat to feed the animals and entertain the public. However, World War II put an end to the excess meat available for feedings, and by 1942, a temporary hiatus turned into the permanent shutdown of Gay's Lion Farm.

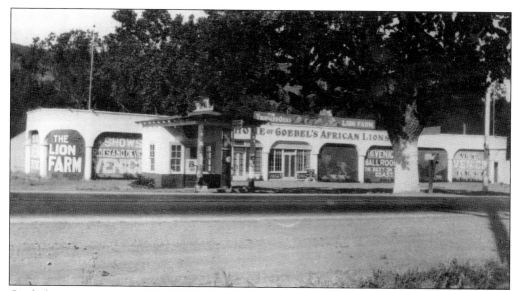

Goebel's Lion Farm went through several name changes over the years. At the time of this photograph, it was known as Thousand Oaks Lion Farm—Home of Goebel's African Lions. After working for Gay's Lion Farm, Louis Goebel worked for Carl Laemmle, who kept a personal zoo at home in Universal City. Serving as a cage boy, Goebel's duties included butchering meat, feeding the animals, and keeping up the grounds. When Goebel learned that the zoo would disband, he decided to purchase six lions and a fox, as well as several dogs, chickens, and rabbits. (Courtesy of Thousand Oaks Library.)

Goebel's original six African lions were named Andy, Bill, Little Cesar, Min, Momma, and Poppa. A seventh lion, Baby, was soon added after showing up on Goebel's doorstep. Unable to get a permit to keep wild animals on land near Agoura, Goebel turned to the sparsely populated and undeveloped town of Thousand Oaks. The town was so new and so unnewsworthy that Goebel had a hard time convincing Ventura County officials that the town of Thousand Oaks even existed. Finally, while explaining to the sheriff, Bob Clark, that the area could be reached by "driving up a crooked road to the top of the hill," Clark realized he was talking about a "godforsaken place" far enough away that the animals would not bother anyone.

Soon after purchasing five lots for $10 each in 1926, Goebel began construction on cages and a large building for community events that would include dances and weekend get-togethers. By 1935, Goebel's Wild Animal Farm included 43 lions, four leopards, six camels, and one tiger. Goebel was always buying and selling animals, so the park's population fluctuated. He once bought 26 elephants, only to sell them as soon as a buyer was found.

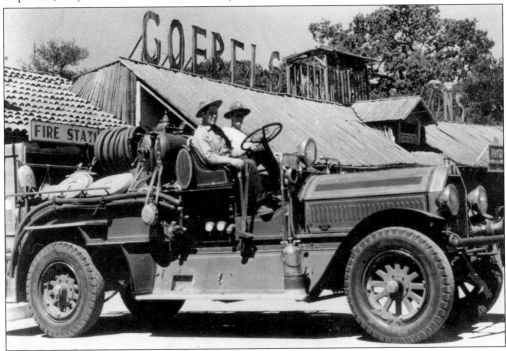

Goebel equipped his farm with a fire department after the fatal fire of July 8, 1940, a hot and windy Santa Ana day. A barn housing some of the animals and stacked with dry hay burst into flames. The fire was later determined to be the result of spontaneous combustion. Trainer Louis Roth was able to save several of the wresting lions, but a petrified camel, six Bengal tigers, and popular elephants Bonnie, Dutch, Sally, and Quennie all perished in the flames. Shown in the fire engine are Case Roper (left) and Roderick Billion. (Courtesy of Thousand Oaks Library.)

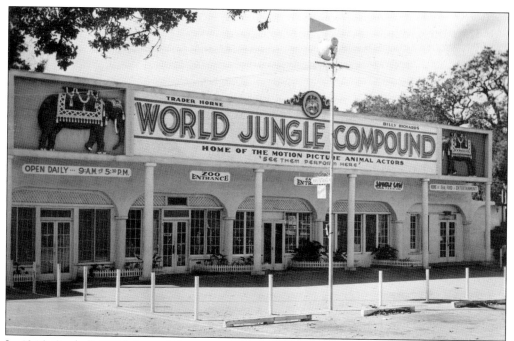

In 1946, Goebel's Wild Animal Farm was sold to Trader Horne and Billy Richards. Horne was an animal importer and made over 50 trips around the world to collect exotic animals. Richards was manager of the Al G. Barnes Trained Wild Animal Circus. He also owned the Selig Zoo in Los Angeles. They renamed the park World Jungle Compound. (Courtesy of Richard and Tuve Kittel.)

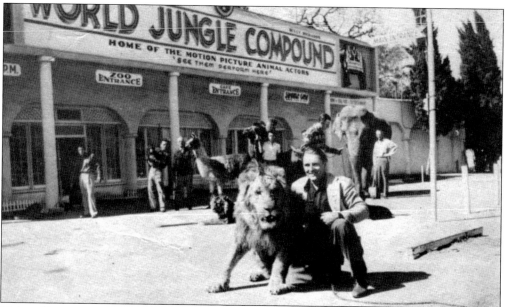

Melvin Koontz poses next to Jackie, one of the MGM mascot lions. Koontz began his training at Billy Richards's Selig Zoo when he was 16. He took his talents to the 1939 world's fair in New York and followed Richards to the World Jungle Compound in 1946. (Courtesy of Stagecoach Inn and Conejo Valley Historical Society.)

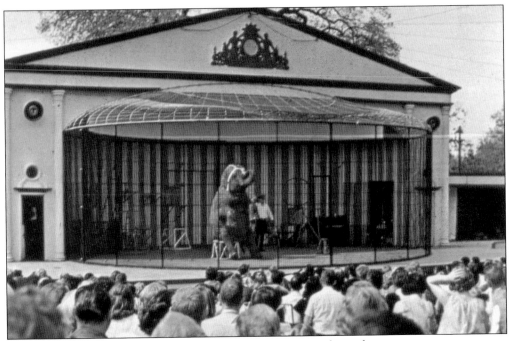

The Great White Stage was the scene of the main events at the park.

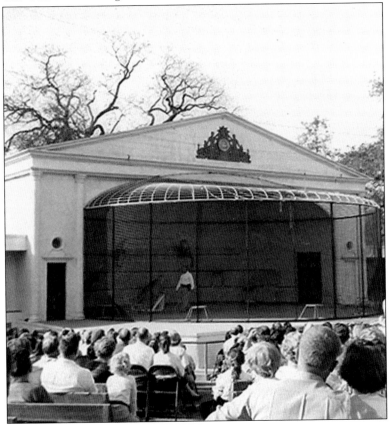

The park was open from 9:00 a.m. to 5:00 p.m. every day except Monday. Kids 12 years old and under were admitted for 50¢. This view shows the main stage. Lou Regan performs with his lions sometime around the 1960s.

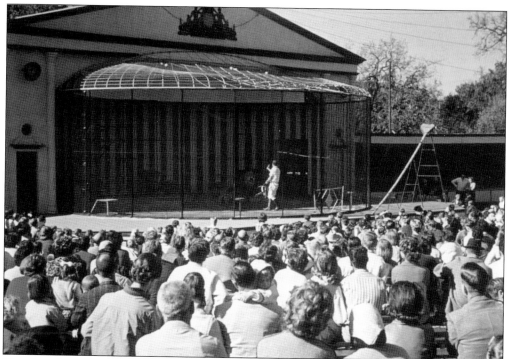

The show known as the Wild Animal Circus started at 1:30 p.m. and lasted until 4:30 p.m. on Sundays and holidays. Animal training took place from 10:00 a.m. to 2:00 p.m. In this picture, Richard Walker performs on the main stage around the 1960s. (Courtesy of Stagecoach Inn and Conejo Valley Historical Society.)

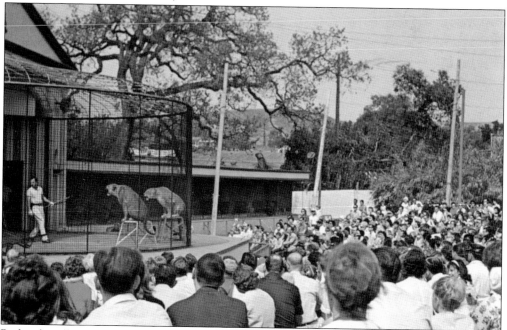

Richard Walker performed with nine lions, and his act included the use of whips, guns, pedestals, and barrels. His featured lion was named Johnny. (Courtesy of Thousand Oaks Library.)

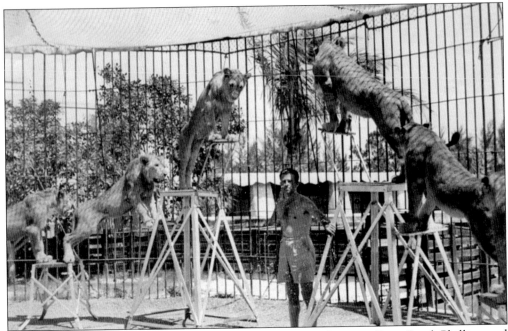

Unlike the majority of trainers who used whips and guns at the time, Capt. Frank Phillips used a whip and a chair to coax his animals. Phillips used the four points of the chair legs as a way to distract the animal and the loud crack of the whip to get the animal's attention. (Courtesy of Richard and Tuve Kittel.)

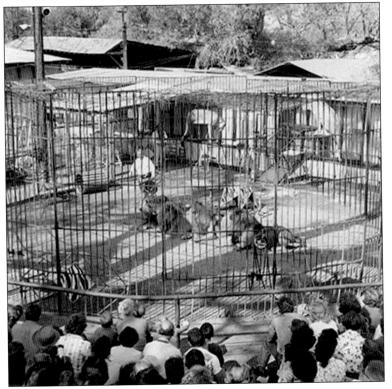

In addition to Capt. Frank Phillips, numerous big-cat trainers have passed though the gates of the iron cages at the wild animal farm. They include: Pat Anthony, Charles Bennett, Albert Fleet, George Fraser, Joe Horwath, Charles Juszyk, Melvin Koontz, Earl LeGrand, Lewis Reed, Stefano Repetto, Louis Roth, Ada Smieya, Roger Smith, Mabel Stark, Richard Walker, and Hubert Wells. (Courtesy of Richard and Tuve Kittel.)

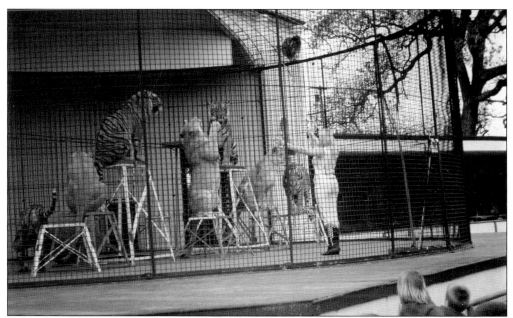

Ada Smieya performs her act with several Bengal tigers. Smieya worked under the tutelage of world-renowned trainer Mabel Stark. Smieya's act included riding the tigers, getting them to jump through a ring of fire, and a new feat never before performed, walking the tigers on a wire. As a reward, the tigers received a kiss from their trainer. (Courtesy of Stagecoach Inn and Conejo Valley Historical Society.)

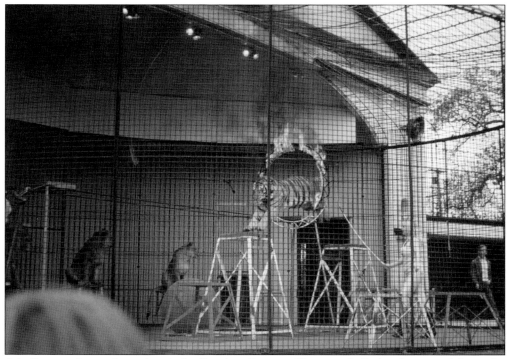

Ada Smieya also performed with the Ringling Bros. and Barnum & Bailey Circus and, later, the Royal Hanneford Circus. (Courtesy of Stagecoach Inn and Conejo Valley Historical Society.)

In 1952, Capt. Frank Phillips took a break from performing at the World Jungle Compound to travel to Japan with Edwin Kane (E.K.) Fernandez and his All American Circus. (Courtesy of Richard and Tuve Kittel.)

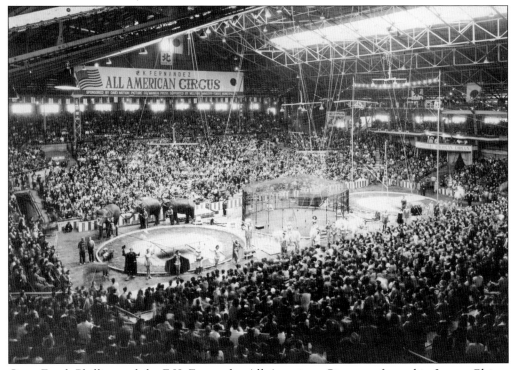

Capt. Frank Phillips and the E.K. Fernandez All American Circus performed in Japan, China, the Philippines, and India. They performed in front of more than 1.3 million people in Tokyo alone. (Courtesy of Richard and Tuve Kittel.)

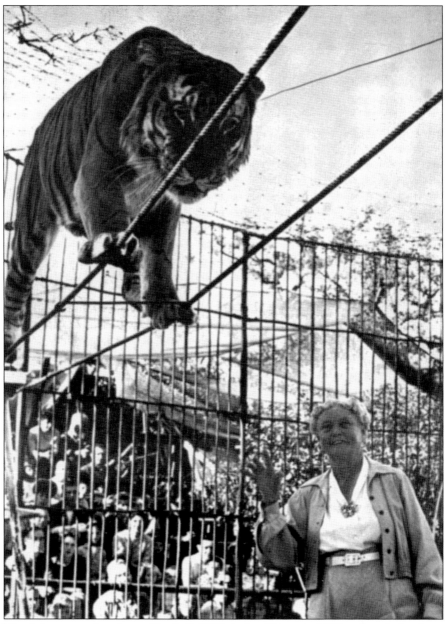

Mabel Stark began performing at Goebel's Wild Animal Farm in 1938 and made her last call in 1968. (Courtesy of Richard and Tuve Kittel.)

Trapeze artists Fred Nuesca and Rusty Rock performed on the main stage at Jungleland in the 1950s and 1960s. Known as the "Flying Viennas," Del and Babs Graham also regularly performed trapeze acts at Jungleland during the same era. They trained television stars Dave and Ricky Nelson, who used their trapeze skills on an episode of *Ozzie and Harriet*. (Courtesy of Thousand Oaks Library.)

Fred Nuesca (left) and Rusty Rock perform in this photograph from 1957. (Courtesy of Stagecoach Inn and Conejo Valley Historical Society.)

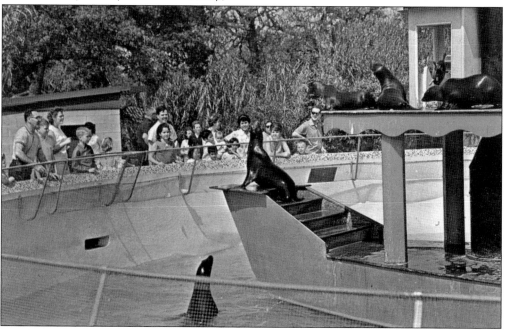

Freddy and Benny, the seals on the left, perform for their dinner. The subtitle for this photograph is "Greatest moochers around."

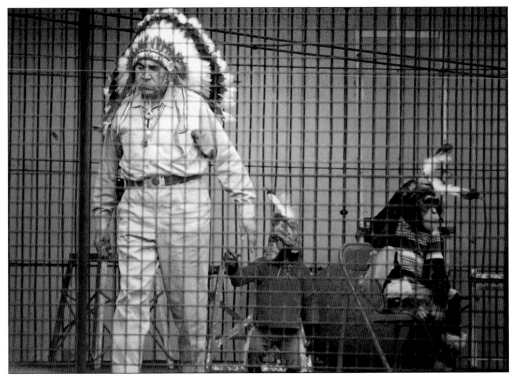

Henry Tyndall was a longtime trainer at both the World Jungle Compound and Jungleland. Chimpanzees and the kangaroos were among the many animals Tyndall trained and cared for. Tyndall was also one of the main trainers for Peggy, the chimpanzee who replaced Tamba. Peggy was featured in *Bonzo Goes to College* and several of the Jungle Jim films. Henry's brother Norman worked in the concessions area. (Courtesy of Thousand Oaks Library.)

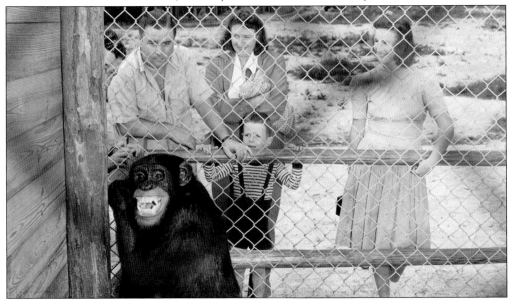

Many chimpanzees became well known and widely used in the entertainment business, including Tamba, Peggy, Kimbo, Neil, Emil, and Little Chim. (Courtesy of Richard and Tuve Kittel.)

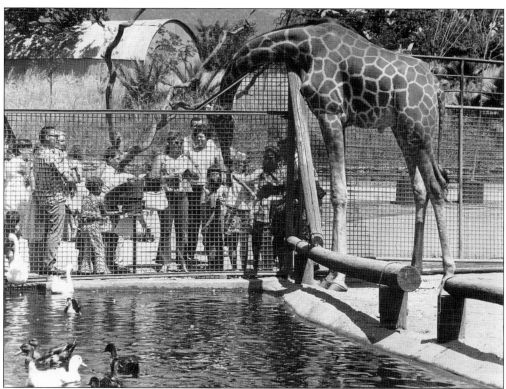

Feeding the animals was part of the attraction of coming to Jungleland. Patrons could purchase food from a vending machine and offer it to the animals.

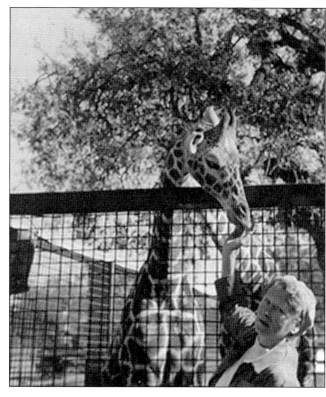

Mabel Stark feeds one of her tall friends during her off-hours. Henry the giraffe was featured in the park's 1960s literature. (Courtesy of Richard and Tuve Kittel.)

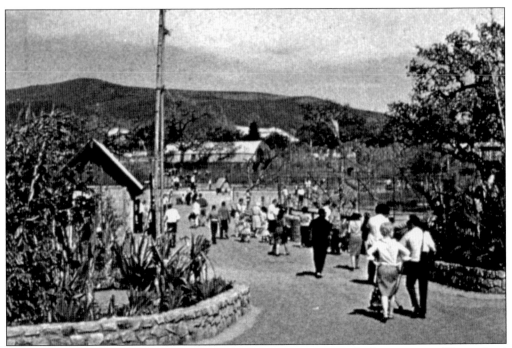

Jungleland faced much competition through the years, starting with the opening of Disneyland in 1955. Several attempts to spruce up the park were made to help compete with the ever-growing competition. (Courtesy of Thousand Oaks Library.)

With Jimmy Woods as manager of Jungleland, which had recently been purchased by 20th Century Fox employees James Ruman and Sid Rogell in 1955, plans were announced to create a sort of Disneyland with live animals. (Courtesy of Thousand Oaks Library.)

It was decided to add 20 acres to Jungleland. Planners envisioned a 178-acre park with a tramway that looped around the compound and across the newly completed 101 Freeway.

The upgraded park would offer a section called Safari Land, where visitors could view the animals in their natural habitat. (Courtesy of Thousand Oaks Library.)

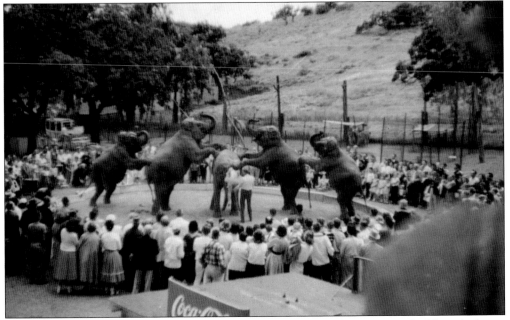

The elephant ring was located outside the central arena. The show consisted of five elephants performing synchronized stunts—such as kneeling, reclining, and circling the ring—while one elephant held the preceding elephant's tail in its trunk. (Courtesy of Stagecoach Inn and Conejo Valley Historical Society.)

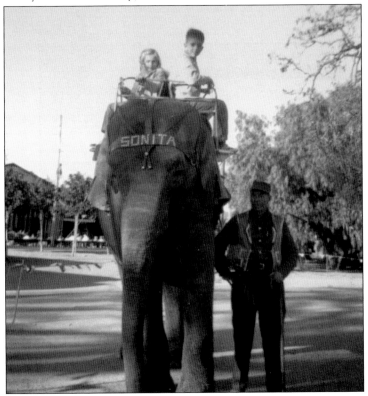

Elizabeth and David Wilson take a ride on Sonita the Elephant at Jungleland in January 1964. Elephant rides were 75¢ per person, with no single riders and no refunds. (Courtesy of Conejo Through the Lens, Thousand Oaks Library.)

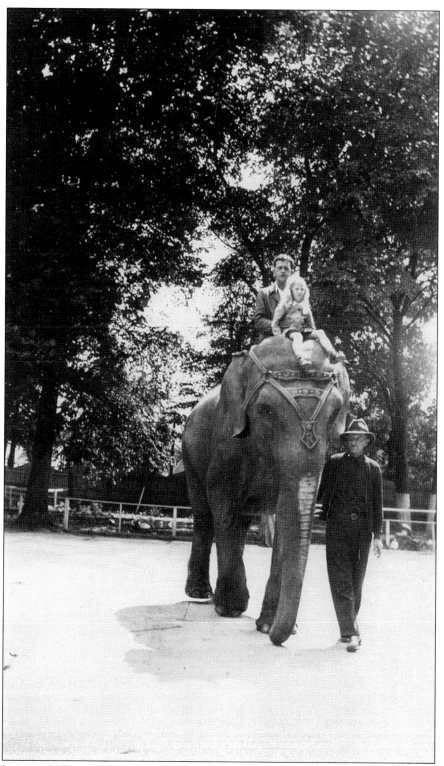

This photograph shows a father and daughter taking a guided tour with a pachyderm view.

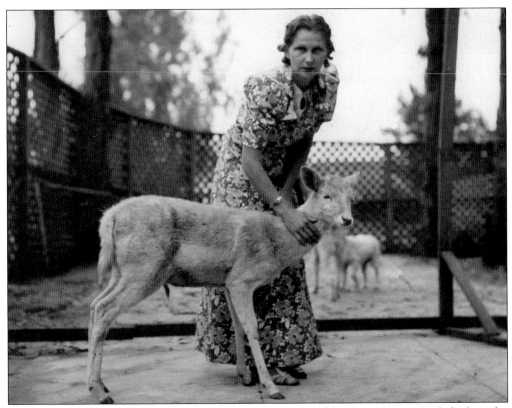

Kathleen Goebel is settling a young deer in this image. Kathleen met Louis Goebel when she went to his house to complain that his roaring lions were interfering with the milking of her cow. When she met the young animal lover, Kathleen said it was love at first sight. The admiration was mutual, and the two were married on June 20, 1928. (Courtesy of Richard and Tuve Kittel.)

A group of youngsters enjoys a slow stroll on a pack of mules.

Louis Goebel was constantly buying from and selling to circuses and zoos. He even said that he might have purchased an animal from every zoo in the country.

Elizabeth (left), David, and Diane Wilson feed the animals in the petting zoo at Jungleland in January 1964. (Courtesy of Conejo Through the Lens, Thousand Oaks Library.)

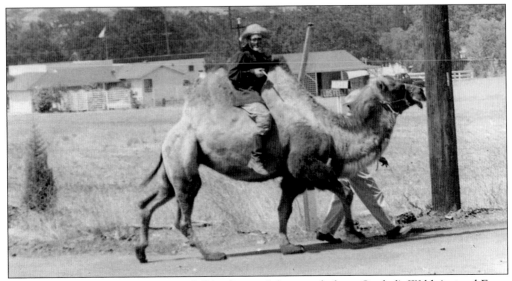

Norman (walking) and Henry Tyndall lead one of the camels from Goebel's Wild Animal Farm over to the Conejo School for a Christmas pageant around 1940. (Courtesy of Conejo Through the Lens, Thousand Oaks Library.)

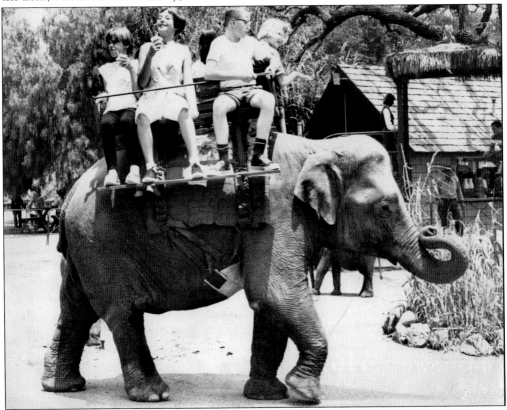

The elephant rides at Jungleland could accommodate six children at one time. Also available were tortoise and mechanical animal rides. (Courtesy of Stagecoach Inn and Conejo Valley Historical Society.)

Anna Muller (sometimes spelled Mueller) takes a young elephant for a walk. Anna and her husband, Rudy, came to Thousand Oaks in 1946 to work at the World Jungle Compound. They were trainers and performers with backgrounds in the circus. The Mullers put on an elephant, dog, and pony act.

Patricia Craig was honored as the 1948–1949 queen of Circus Days at the World Jungle Compound. (Courtesy of Stagecoach Inn and Conejo Valley Historical Society.)

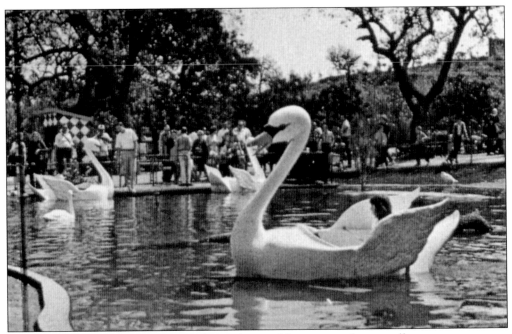

Jungleland also offered rides on swan boats that could seat up to three small youngsters.

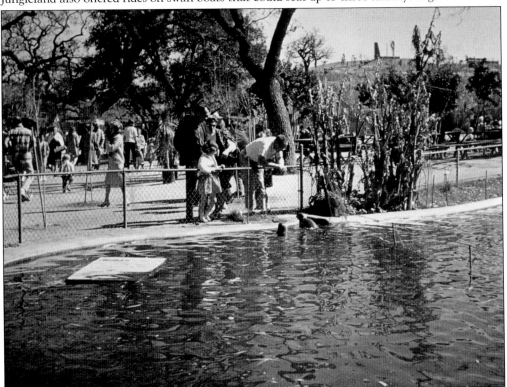

Included among the ranks of Jungleland's trained animals were performing seals. This photograph shows the seal pond at Jungleland. (Courtesy of Stagecoach Inn and Conejo Valley Historical Society.)

Tex Scarborough and his wife ran the concession stand at Jungleland. Before them, Darwin Glenn managed the concessions. In May 1957, the park announced plans to include reproductions of African, Asian, and Middle Eastern jungles, with a marketplace and bazaar offering 100 concessions.

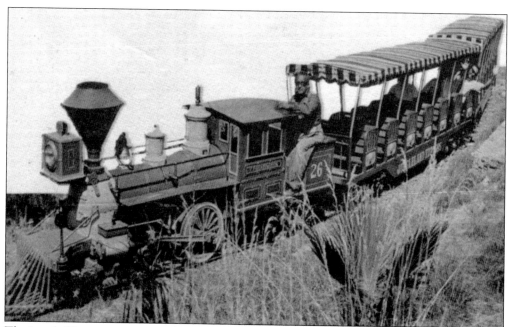

The Jungle Flyer—a miniature, four-cylinder, Chance gas locomotive—circled around the park and through the monkey cage. It had room for 16 passengers.

Isaac Sherman "Trader" Horne was born in 1882. In 1914, he opened the Horne Zoological Arena Corporation in Missouri. After visiting the jungles of Mexico's Yucatan Peninsula with his father, he devoted his life to importing exotic animals from around the world. He supplied animals to circuses, zoos, motion pictures, and William Randolph Hearst's private zoo in San Simeon, California. Horne and Billy Richards purchased Goebel's Wild Animal Farm in 1946. (Courtesy of Stagecoach Inn and Conejo Valley Historical Society.)

W.J. "Billy" Richards was an organizer and manager of the world-famous Al G. Barnes Trained Wild Animal Circus and manager and owner of the Selig Zoo in Los Angeles. Richards used the fields of Venice, California, as winter quarters for the circus animals and offered them for use to the growing motion picture studios proliferating in the Southland. Richards used his expertise to stage animal scenes for circuses and films. In 1956, Richards and Horne sold the World Jungle Compound to Sid Rogell and James Ruman. It was this set of owners who christened the site Jungleland. (Courtesy of Stagecoach Inn and Conejo Valley Historical Society.)

Louis Roth mentored many great trainers, including Mabel Stark, Clyde Beatty, and Bert Nelson. Originally from Hungary, Roth came up with a new technique known as gentling for training animals. Instead of beating the animal, Roth focused on using chunks of horse meat to reward it for trained behaviors. After working with the Al G. Barnes Trained Wild Animal Circus, Roth traveled to California and became chief animal trainer at the Selig Zoo.

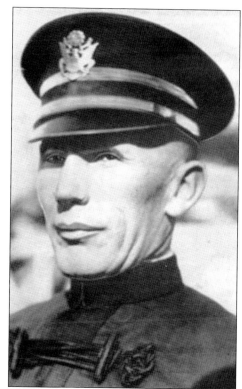

Louis Goebel stands over his original mascot, Leo the Lion. The Jungleland property was sold on three occasions. Each time, Goebel regained the rights after the owners failed to meet their financial obligations. The first sale was in 1945 to Billy Richards and Trader Horne. The second sale was to James Ruman and Sid Rogell of 20th Century Fox. Their associate, Jimmy Woods, had plans to create a Disneyland with live animals. The third attempt to sell was to Roy Kabat and Thurston "Tex" Scarborough. (Courtesy of Stagecoach Inn and Conejo Valley Historical Society.)

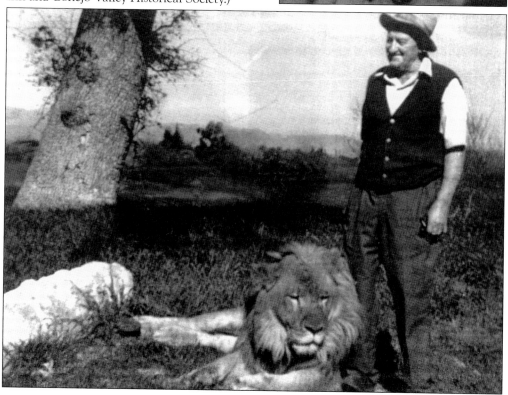

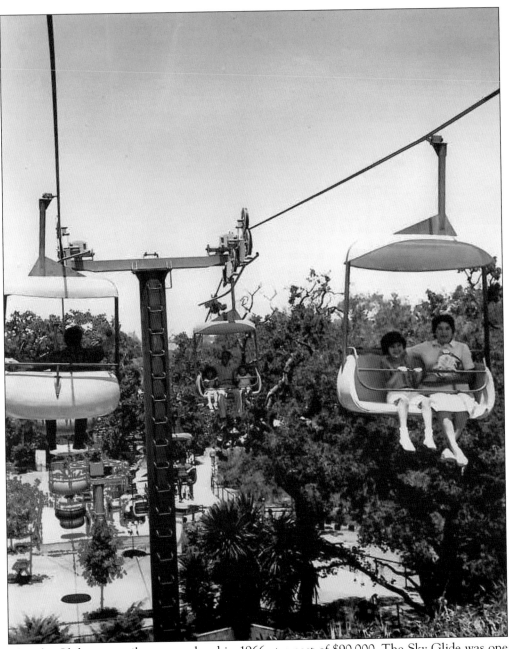

The Sky Glide monorail was completed in 1966 at a cost of $90,000. The Sky Glide was one of many changes to upgrade the property so that it could compete with the growing number of amusement parks in Southern California. (Courtesy of Robin Kabat Dickson.)

Two

TRAINERS AND ENTERTAINERS

Capt. Frank Phillips's first brush with fame came at the age of 20 when he was given the opportunity to care for one of the most famous motion picture actors on the screen, Leo the Lion. Phillips was the son of famous female animal trainer Madame Jewel, who performed with the Hagenbeck and Wallace Circus. At the age of 15, Phillips made his first public appearance while performing with wild animals from the Walter L. Main Show. The captain title may have come from his association with the Kingston Armory in New York, where he was in charge of training a large menagerie of wild animals for the Ringling Bros. and Barnum & Bailey Circus. His title was definitely related to his ability to captain a variety of animals. (Courtesy of Richard and Tuve Kittel.)

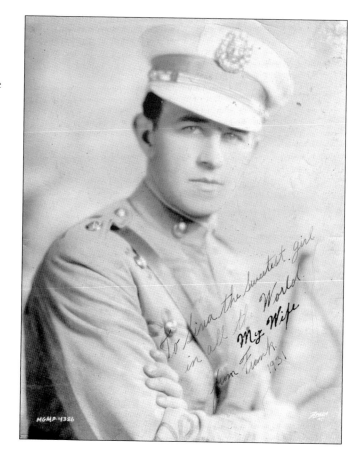

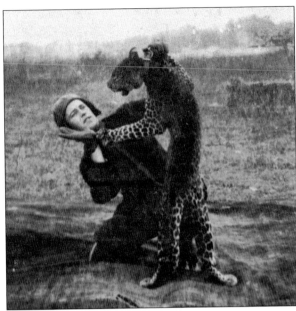

As part of his act with the Sparks Circus, Capt. Frank Phillips wrestled a leopard, as shown in this photograph from 1929. At an early age, Phillips learned from his mother about the habits and traits of many different animals. Despite his training, Phillips made many trips to the hospital—approximately 50 in his lifetime, 23 in one year alone. (Courtesy of Richard and Tuve Kittel.)

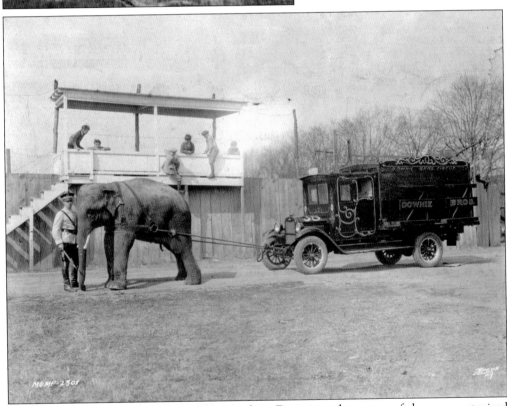

The Downie Bros. Circus was owned by Andrew Downie and was one of the new motorized circuses. Instead of shelling out $500 a day to move his circus, Downie invested in light trucks. Trucks carrying less than two tons each moved Downie's circus gear across country back roads and to the next town. Frank Phillips was part of this entourage in 1926 and 1927 and again in 1930. (Courtesy of Richard and Tuve Kittel.)

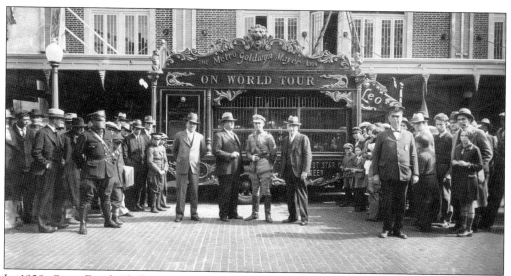

In 1928, Capt. Frank Phillips and Leo the Lion, MGM's trademark symbol, toured the world, including the North and South Americas, Europe, Asia, and Australia. The powerful and majestic Leo was the first image the public saw when they entered the new world of motion pictures. The 750-pound lion measured nine and half feet from his nose to the end of his tail. (Courtesy of Richard and Tuve Kittel.)

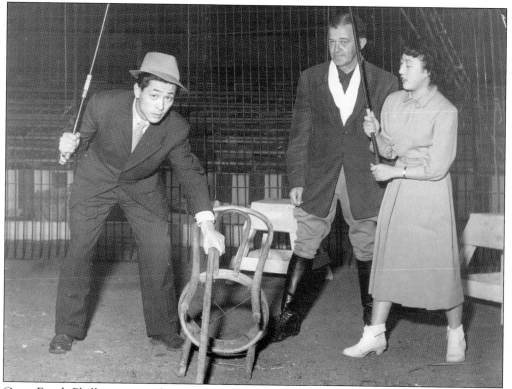

Capt. Frank Phillips returned to Japan in the 1950s and was greeted with a packed house at each performance. This photograph shows Phillips standing back to observe his pupils after demonstrating his technique. (Courtesy of Richard and Tuve Kittel.)

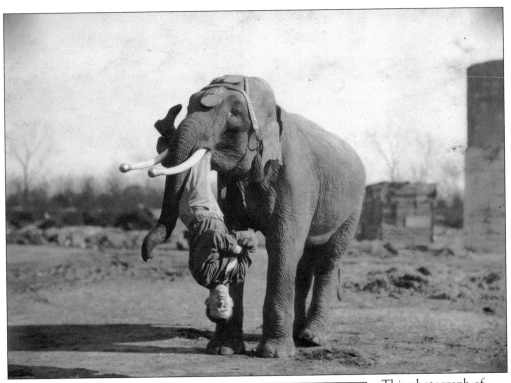

This photograph of Capt. Frank Phillips dates back to 1931. This stunt led to him being featured in the newsreels that played before motion pictures. (Courtesy of Richard and Tuve Kittel.)

n the bottom Come on d

Capt. Frank Phillips takes the low road with his elephant friend. This c. 1930 image features Teddy, one of five bulls trained by Phillips, during his tenure with Downie Bros. Circus. Phillips's elephant act was abandoned after he sustained a concussion from being carried by his head (as seen on the cover of this book). (Courtesy of Richard and Tuve Kittel.)

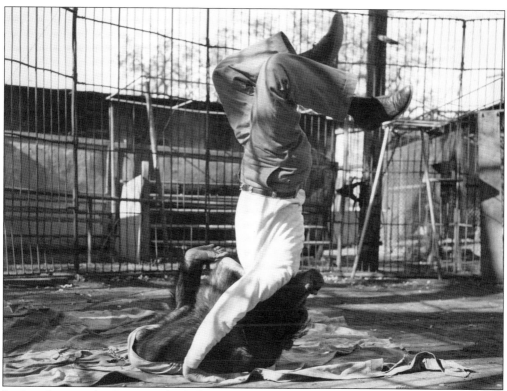

In this photograph, Capt. Frank Phillips has enlisted a chimpanzee for help with a headstand. (Courtesy of Richard and Tuve Kittel.)

One of the most popular events at the park was feeding time. Fortunately, this trainer was not part of the meal. Feeding took place following the show and included 900 pounds of fresh horse meat. An adult lion can eat up to 88 pounds in one meal. (Courtesy of Richard and Tuve Kittel.)

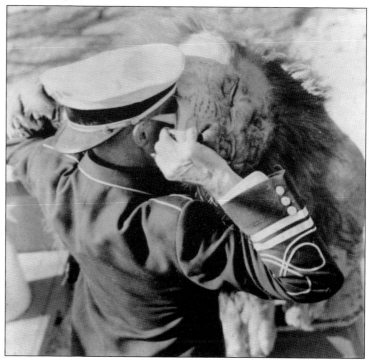

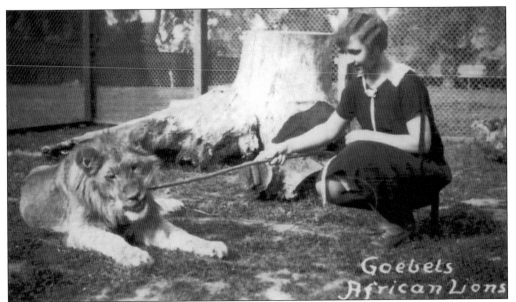

Kathleen Goebel, wife of Louis Goebel, also had a passion for animals. The Goebels kept many animals in and around their home. On one occasion, son Eugene fell off a chair and tumbled into one of the open cages of a sleeping lion. The adolescent boy promptly picked up the lion's tail and bit it. Luckily, the groggy cat was slow to respond. After the close call, the Goebels were quick to move off the compound to a new location that was safer for mischievous children. (Courtesy of Stagecoach Inn and Conejo Valley Historical Society.)

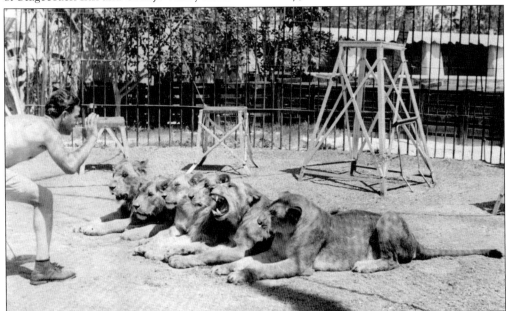

Accidents are a part of any trainer's experience. During his lifetime, Capt. Frank Phillips was injured numerous times. His index finger was bitten in half by Leo the Lion; he was impaled through his thigh by a red deer; his skull was fractured by an elephant; and a lion had to be shot as it chewed on him. However, his biggest scare came when he was painting the lions' cage and a black widow spider bit him. (Courtesy of Richard and Tuve Kittel.)

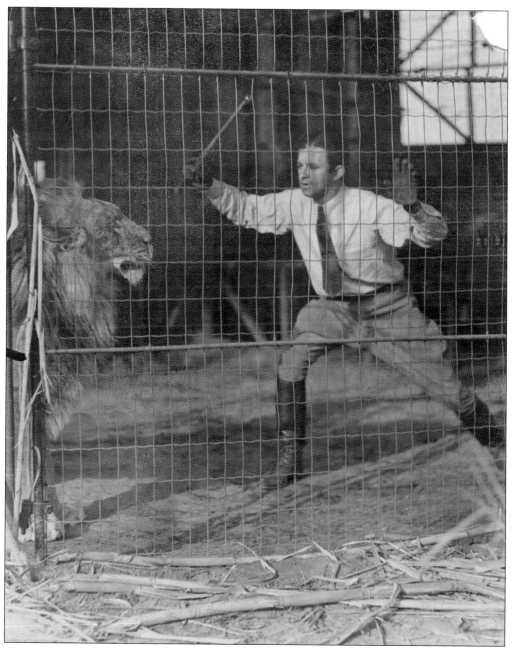

Capt. Frank Phillips's connection to Jungleland started with Leo the Lion. Leo arrived at the park in the 1930s, about 10 years before Phillips, who came in the 1940s. Phillips befriended neighbor Richard Kittel. When Phillips passed away, his widow, Siva, offered Kittel memorabilia from Phillips's archives. Many of Phillips's pictures that were passed on to Kittel are featured in this book. (Courtesy of Richard and Tuve Kittel.)

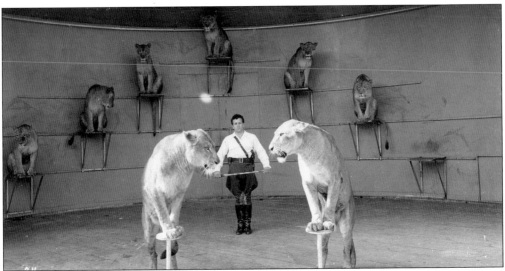

This photograph shows Pat Anthony. He was billed as the only GI Wild Animal Trainer and used a stick and a pair of pistols for his show. He also worked on many movies, including a circus movie in which Anthony Koontz and Melvin Koontz fought in a cage full of lions. In retrospect, the trainers realized they could have been victims very easily if the lions had reacted. Anthony went on to work on many films, including *The Greatest Show on Earth*, wrestling wild hyenas in *The Snows of Kilimanjaro*, and grappling with a mountain lion in *River of No Return*.

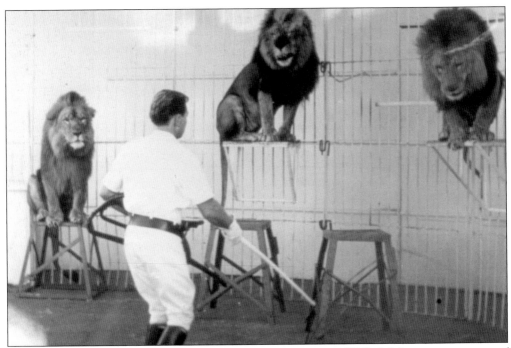

Hubert Wells takes his turn at taming lions in this 1960s image. Wells left his native country of Hungary in 1957 to escape communism. He worked on multiple movie sets, from *Doctor Doolittle* (1967) to more recent films like *Out of Africa* (1985) and *Babe: A Pig in the City* (1998). (Courtesy of Thousand Oaks Library.)

Capt. Frank Phillips appeared in hundreds of movies as stuntman for the stars. He doubled for Barton MacLane in *The Bengal Tiger* (1972). Phillips often marveled that the actor always got a double, but the animals did not. Of all the animals Phillips trained, lions were his favorite: "Give me a lion anytime. They're the best. They fight fair and square." (Courtesy of Richard and Tuve Kittel.)

This picture is labeled on the back as "Barton MacLane" and comes from the archives of Capt. Frank Phillips. Here, MacLane gets in the cage before Phillips, his stunt double, finishes the scene. (Courtesy of Richard and Tuve Kittel.)

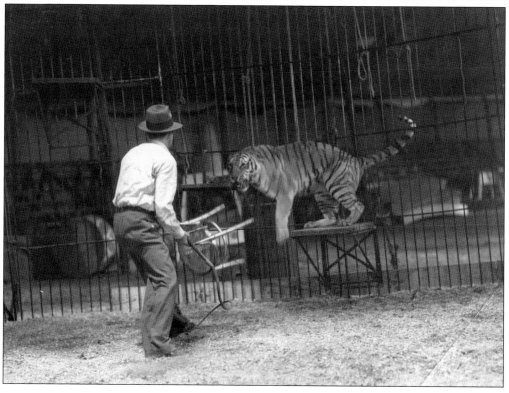

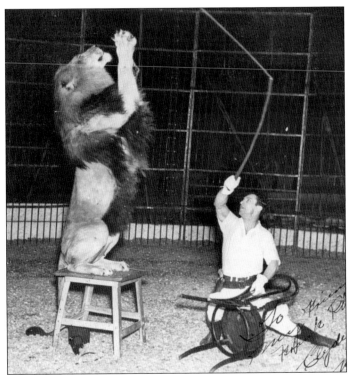

Clyde Beatty was a good friend of Capt. Frank Phillips and signed over this photograph to Phillips. Beatty was trained under Louis Roth but chose a more flamboyant approach to his performance. While Phillips and Roth showed off the powerful and dynamic relationship between the lion and the trainer, Beatty demonstrated his power and courage over the animal. He was a showman. Beatty started his own circus, appeared in dozens of movies, and wrote several books. Beatty performed at Jungleland in 1960. He passed away in 1965 in Ventura, California. (Courtesy of Richard and Tuve Kittel.)

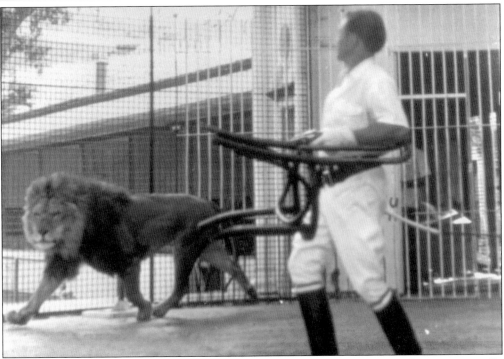

Hubert Wells was trained as a falconer before fleeing to the United States from Hungary. In the early 1960s, Wells was an assistant to the trainers at Jungleland. He soon graduated to the performance stage. (Courtesy of Thousand Oaks Library.)

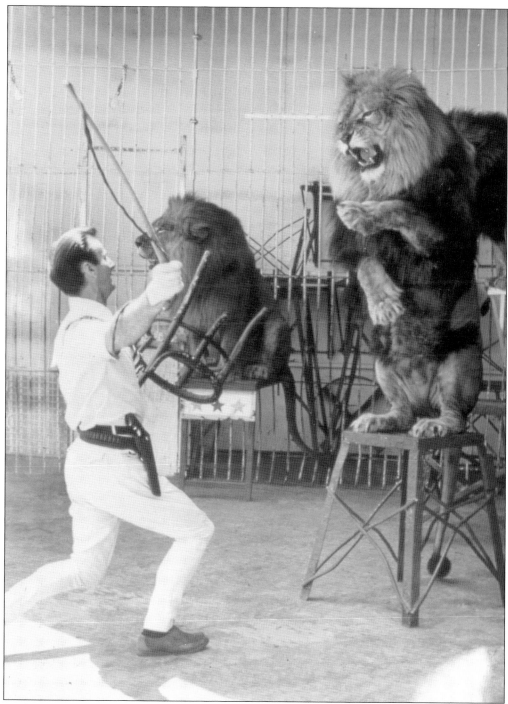

Herbert Wells was known for wearing his khaki outfit with tall black boots. He worked on dozens of movies, including *Big Top Pee-Wee* (1988). Wells orchestrated the scene in which a menagerie of animals jogged together while dressed in peculiar clothes.

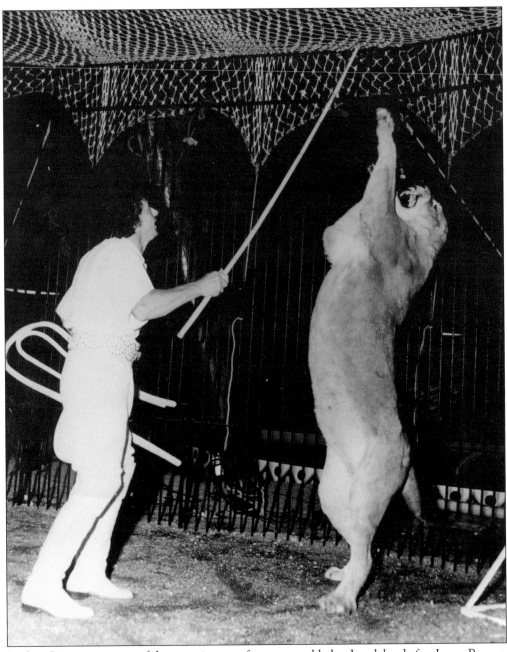

Stefano Repetto was part of the new circus performances added to Jungleland after James Ruman and Sid Rogell purchased the World Jungle Compound in 1955 and renamed it Jungleland. Repetto was advertised as the Italian trainer. Here, Repetto works with Johnny, the wire-walking lion. (Courtesy of Thousand Oaks Library.)

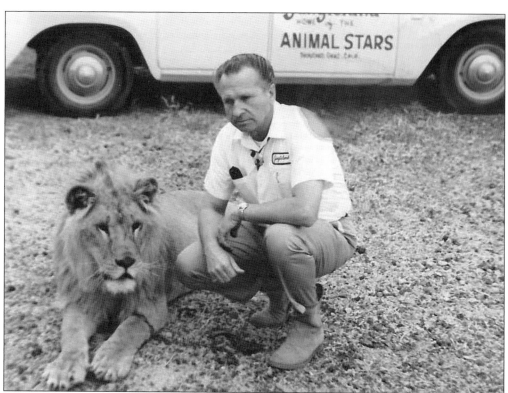

Roy Kabat poses with Jackie, one of the MGM lions. Kabat produced television shows *Chucko the Clown* (1954–1962) and *Circus* (1978–1985) and became involved with Jungleland during the 1950s as a manager of the park. He worked on the sets of many films, including *Doctor Doolittle* (1967), *Born Free* (1966), and *Escape from the Planet of the Apes* (1971), where he trained the animals, not the apes. (Courtesy of Robin Kabat Dickson.)

Stewart Raffill wrestles with a lion at Jungleland during the 1960s. Raffill trained Major the lion for the *Tarzan* movies and even starred as Tall Boy in the *Tarzan* television series (1966–1968). Raffill went on to become a prolific writer and director of movies. The 1988 film *Mac and Me* has gained cult status as one of the worst movies ever made. On the opposite spectrum, *The Philadelphia Experiment* won the award for best film at the 1985 Fantafestival. (Courtesy of Robin Kabat Dickson.)

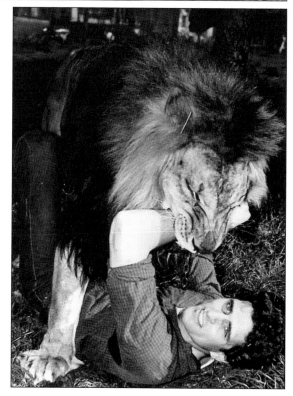

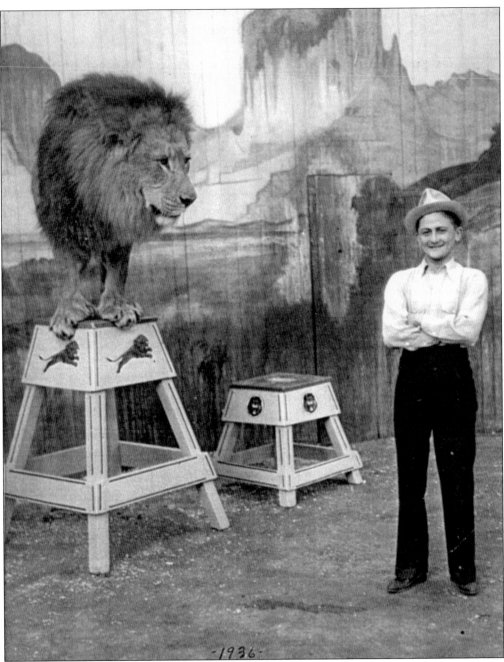

-1936-

Racehorse jockey Don Meade won the Kentucky Derby in 1933, and for a period in the 1930s and 1940s, he was considered one of the greatest jockeys of all time. However, controversy followed Meade. In his 1933 victory, an 18-year-old Meade was involved in a confrontation with second-place jockey Herb Fisher. The two grabbed, pushed, and shoved each other down the stretch. Meade had earned three lifetime bans from racing by 1945 when he turned his attention to Jockey Meade's Kentucky Derby, his business in Thousand Oaks. In this photograph, Meade steps into the cage with one of the lions from the World Jungle Compound. (Courtesy of Thousand Oaks Library.)

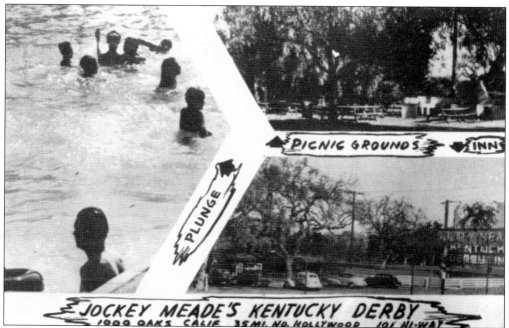

Jockey Meade opened the Kentucky Derby Inn in Thousand Oaks in the 1940s. The inn's name changed to the Meadowbrook Plunge in reference to the large public pool. However, the establishment was most commonly known as Jockey Meade's. The inn was across the street from Jungleland. Terry Kennedy remembers being at Meade's when a fire broke out at Jungleland and later learning that Tamba, the chimpanzee star of *Bedtime for Bonzo*, had died in the blaze. (Courtesy of Thousand Oaks Library.)

Jean Wilson Maulhardt visited Jockey Meade's for senior ditch day with friends Shirley Hehir, Valarie McGill, Marylyn Schmidt, and others from the class of 1953 at Ventura High School. In addition to being a getaway destination, the Meadowbrook Plunge was where many residents from around the county learned to swim.

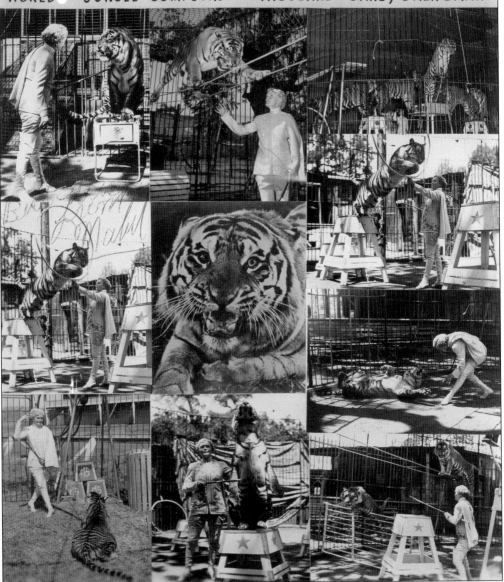

MABEL STARK AND HER TIGERS
ONLY WOMAN TIGER TRAINER
WORLD JUNGLE COMPOUND — THOUSAND OAKS, CALIFORNIA

Mabel Stark was a top attraction for the park from 1938 to 1968. Born in Kentucky on December 9, 1889, Stark's given name was Mary Haynie. Her parents died, leaving Stark orphaned by the age of 17. After a short stint as a nurse, she turned to the circus and never looked back. Working at first as a dancer and a horseback rider, her goal was to work with the big cats. By 1911, Stark was in Culver City and employed by the Al G. Barnes Trained Wild Animal Circus. After meeting cat trainer Louis Roth, Stark began learning the intricacies of working with tigers. (Courtesy of Richard and Tuve Kittel.)

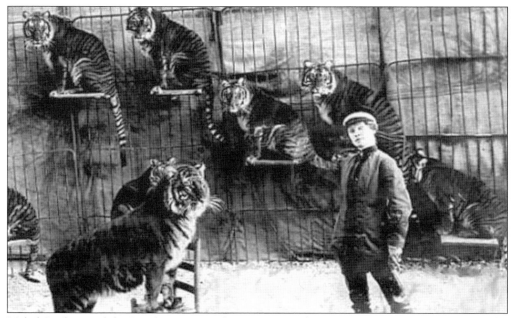

Mabel Stark joined the Ringling Bros. and Barnum & Bailey Circus in 1922. By the next year, she was featured in the center ring, performing at Madison Square Garden. Part of her act included a wrestling match with Rajah, her adopted male tiger. Rajah would grab Mabel by the neck, as he would a female feline that interested him, and the two would roll around while he growled and completed his action.

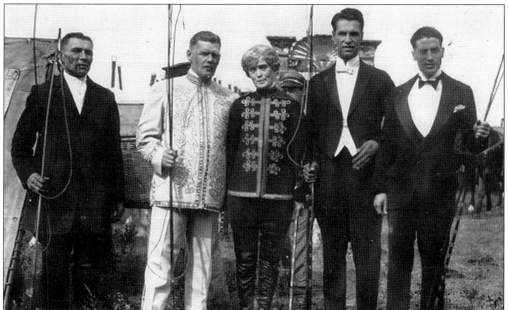

By 1928, Mabel Stark began working with the John Robinson Show. During this same year, she slipped while working with tigers in a cage and suffered the worst of her many maulings. Severe injuries resulted from the attack, including a torn deltoid muscle, a punctured shoulder, face lacerations, and a nearly severed leg. Despite this near fatality, a bandaged Mabel returned to the ring in a few weeks, walking with the help of a cane.

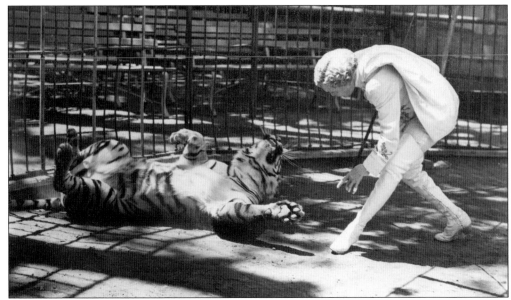

Mabel Stark had many titles, including The Most Famous Lady Trainer, The Fighting Lady of the Big Top, and The World's First Woman Tiger Trainer-Tamer. Though there is little argument on who was the premier lady lion trainer, several came before Stark. Rose Flanders Bascom began training tigers in 1905 but died from an infection after being clawed in 1915. Bascom's opportunity in the limelight came after another lady cat trainer, Marguerite Haupt, died. (Courtesy of Richard and Tuve Kittel.)

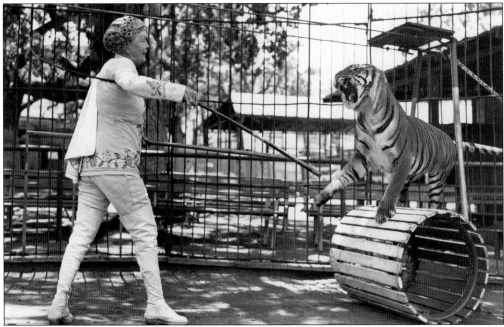

Despite being attacked 18 times in her life, Stark never blamed the tigers. As she stated in her autobiography from 1938, "I have been clawed and slashed and chewed until there is hardly an inch of my body unscarred by tooth or nail. But I love these cats as a mother loves her children, even when they are the most wayward."

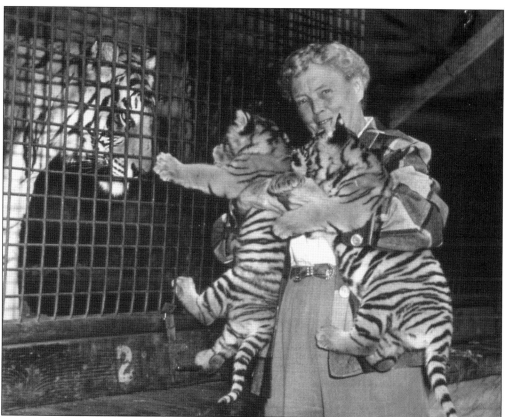

Stark went on to say, "I blame myself, not the tiger if something goes wrong. Maybe it is an ulcerated tooth, a sore paw, or just a grudge against the world for no good reason at all that has upset the cat. Then the fun starts." She also said, "For me there is no greater thrill than stepping into a cage full of those glorious beasts and matching wits with them." (Courtesy of Thousand Oaks Library.)

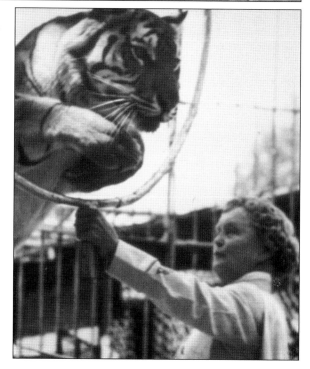

Despite her small stature and the tigers' overwhelming strength, Mabel defended herself with only a whip and her commands. Today, she would be called a tiger whisperer. After one of her maulings, she found out that the cats had not been fed and watered properly, so despite almost losing her life, she was able to forgive them. (Courtesy of Thousand Oaks Library.)

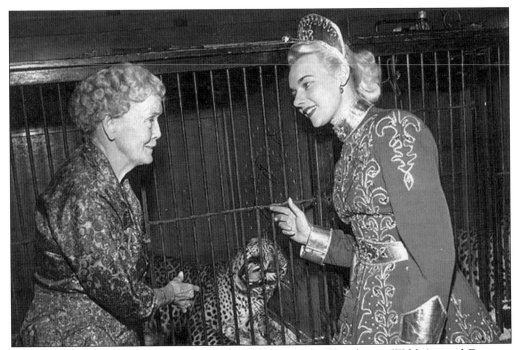

Patricia Jameson (right), a British animal trainer with the Hawthorne Wild Animal Fantasy, meets her idol, Mabel Stark. Jameson's troupe advertised their show as a "unique combination of natural enemies."

Mabel Stark was married four—possibly five—times in her life. Her first marriage was to a wealthy Texan and lasted only a short time. She then married cat trainer Louis Roth. A short-lived union with Albert Ewing, a crooked accountant, followed. Her last marriage was to Eddie Trees, superintendent of animals at Al G. Barnes Trained Wild Animal Circus, who died while touring with Stark in Japan in 1953. Each marriage, she confessed later, was to further her career. But it was her big cats that prompted her to say, "I could find no pleasure or happiness anywhere except with tigers." This sentiment would ring true to her final day. (Courtesy of Robin Kabat Dickson.)

In Mabel Stark's final years, scars covered her body from head to toe, limiting her mobility and relegating her to menagerie trainer. A series of events led Stark to take her own life on April 20, 1968. One source claims the park could not get insurance for the aging trainer. Another reference claims she was fired because of disagreements with the current owners. More likely, the joy of performing was behind her. Before her death, one of Stark's beloved tigers got loose. Instead of coaxing the animal back to the compound, park employees shot the animal, causing Stark much grief. (Courtesy of Richard and Tuve Kittel.)

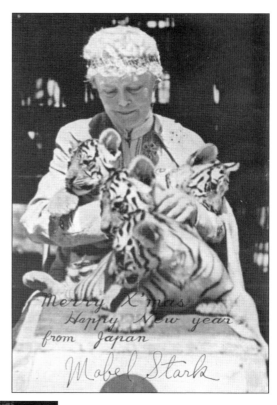

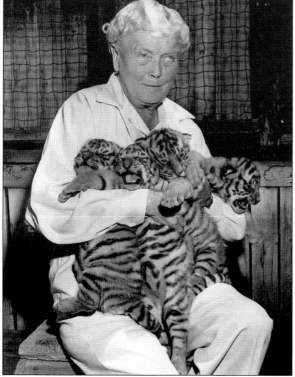

Words from Mabel Stark's autobiography foretold her final wish before she cracked the whip on her own life with a combination of barbiturates and carbon monoxide: "Let them out. Out slink the striped cats, snarling and roaring, leaping at each other or at me. It's a matchless thrill and life without it is not worthwhile to me." (Courtesy of Robin Kabat Dickson.)

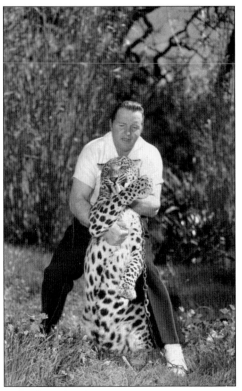

Melvin Koontz was advertised as the chief trainer and peer of all movie animal trainers. His family moved to Los Angeles when he was a teenager, and he found a job at the Selig Zoo selling popcorn. He graduated to cleaning cages and soon after began working with the animals. He worked with Jackie, one of the MGM lions. His resume was enhanced by his appearance at the New York World Fair, where he had a lion act. (Courtesy of Stagecoach Inn and Conejo Valley Historical Society.)

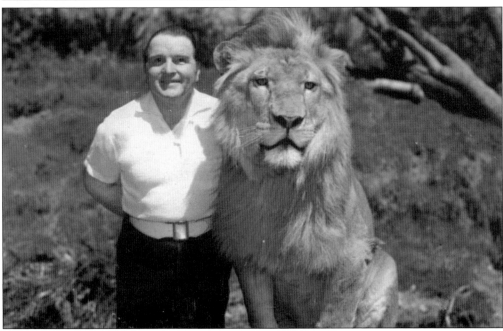

Melvin Koontz claimed to have worked on over 600 films and to have appeared in half of them as a stunt double and bit character. Koontz followed Billy Richards and Trader Horne, the former owners of the Selig Zoo, to the World Jungle Compound in 1946 and then retired in 1964. (Courtesy of Stagecoach Inn and Conejo Valley Historical Society.)

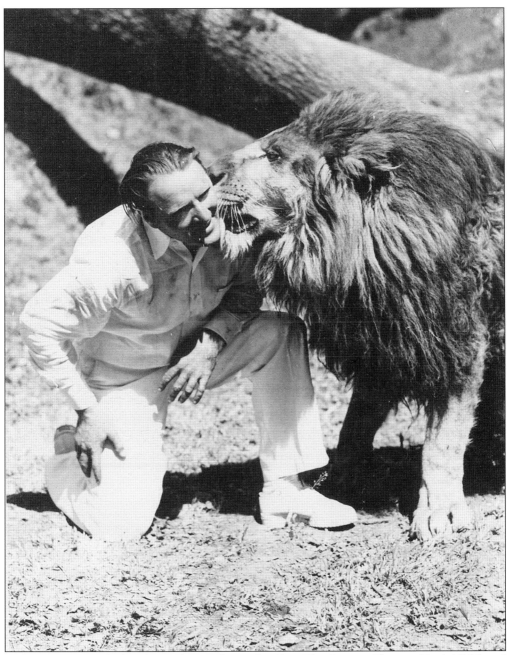

Melvin Koontz worked with Cecil DeMille on the films *The Greatest Show on Earth* (1952) and *Slaves of Babylon* (1952), in which he doubled for Richard Burton. A problem arose when Koontz had to dress in all black for a scene with five lions in a den. Koontz worried his trained lions would not know him and attack. Fortunately, they must have recognized his five-foot stature, as the scene was successful.

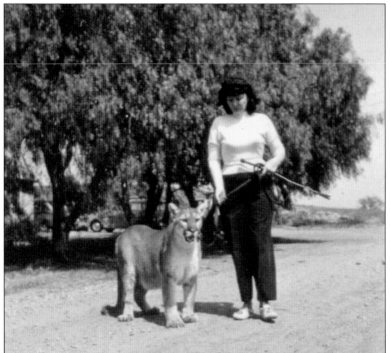

Mildred Koontz takes her "pet" cougar for a walk. Mildred was married to trainer Melvin Koontz, and the cougar stayed at their residence, negating the need for a burglar alarm. (Courtesy of Thousand Oaks Library.)

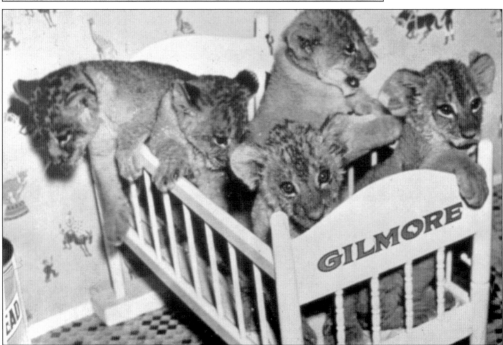

The Gilmore cubs were a part of the Gilmore Oil Company publicity logo. Gilmore Oil became Mobil Oil. The company sponsored Col. Roscoe Turner, a colorful aviator who honed his skills during the 1920s as he barnstormed across the country. He took his talent to Hollywood and starred in several movies, including the Howard Hughes movie *Hell's Angels* (1930). (Courtesy of Thousand Oaks Library.)

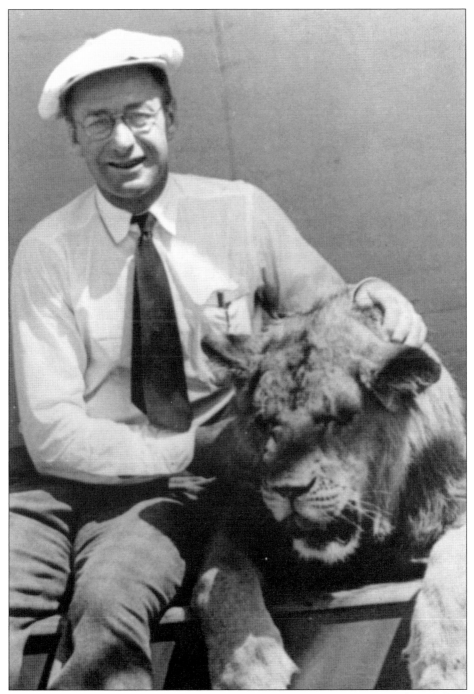

The Gilmore lion frequently toured with Roscoe Turner. As the lion got older and needed a stable home, Turner gave it over to Jungleland, where it lived until its death in 1952. After it died, the lion was stuffed and mounted and returned to Turner. Today, the lion is stored at the Smithsonian Institution. (Courtesy of Thousand Oaks Library.)

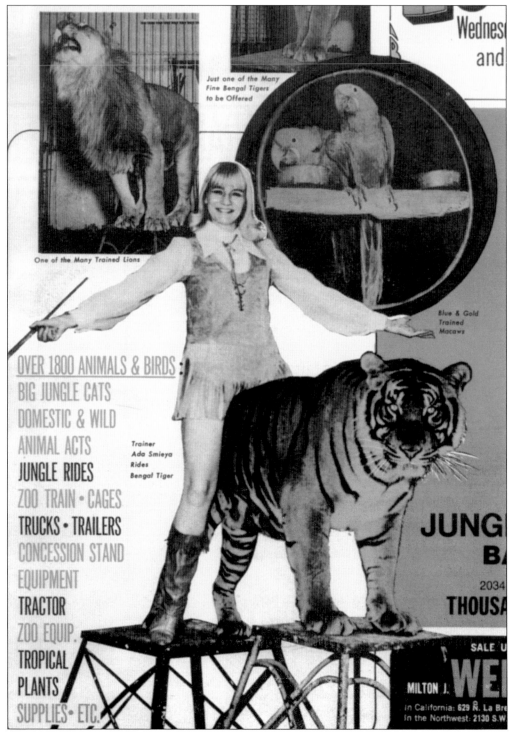

Ada Smieya's two most popular tigers were Rajah and Rowena. Her act grew to 10 Siberian tigers. While touring with the Royal Hanneford Circus, Smieya became known for her spectacular show, which included an act with burning hoops and a high-wire performed by her tigers.

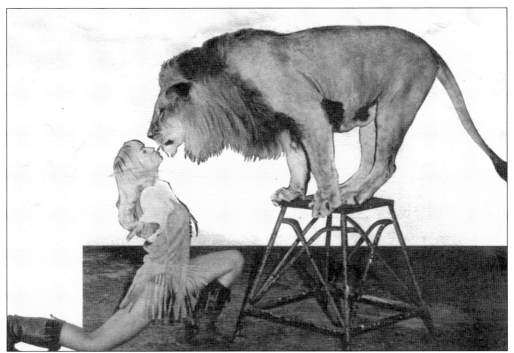

Smieya married Klaus Blaszak, also a lion trainer, and their son Bruno Blaszak followed in their footsteps. At age 16, Bruno performed with his mother as the world's youngest animal trainer, despite having witnessed a lion bite through his mother's arm when he was a boy. His trained tigers have appeared in contemporary commercials and movies and in the television show *Xena: Warrior Princess* (1995–2001).

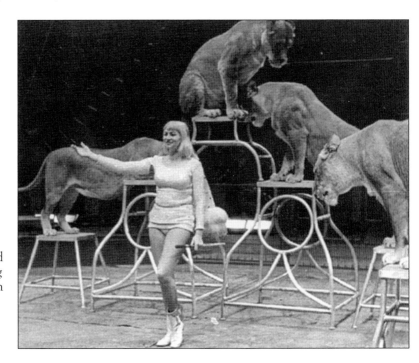

In 1965, Ada Smieya performed with the Ringling Bros. and Barnum & Bailey Circus. Soon after, she was performing at Jungleland.

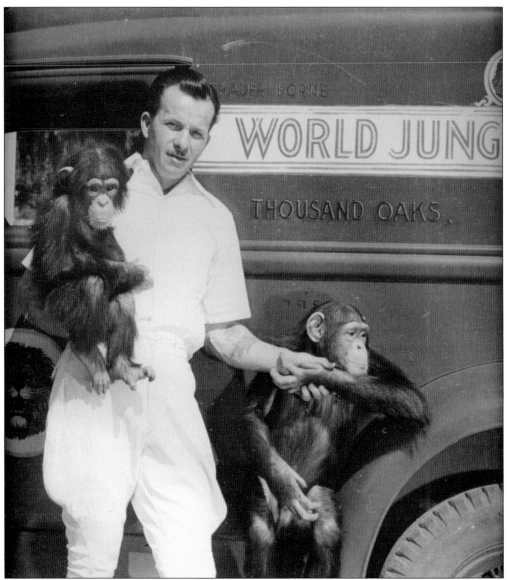

Tony Gentry has become best known as the perpetrator of the Cheetah myth. While Gentry certainly trained many chimpanzees during his tenure, one of his varying claims is that he brought the chimpanzee that played Cheetah in the original Tarzan movies to the United States from the wilds of Liberia in the 1930s. Gentry is said to have given the chimpanzee to a family member, who then donated the aging primate to the Cheetah Primate Foundation in Palm Springs, California. In reality, the chimpanzee in question was about seven years old when it was donated by Malibu's Pacific Ocean Park after it closed in 1967. (Courtesy of Stagecoach Inn and Conejo Valley Historical Society.)

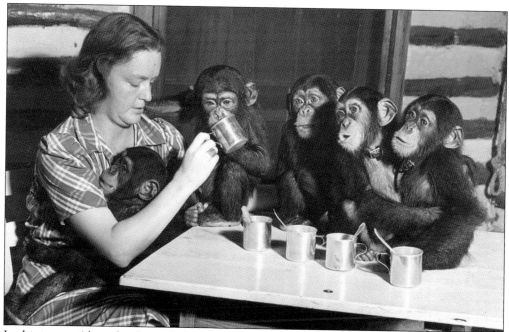

In this image, Alma, daughter of Louis and Kathleen Goebel, feeds five baby chimpanzees. Alma was active in caring for the animals at her home and during her stay at Jungleland. She has continued the legacy of the animal compound her parents created by writing several newspaper articles about her family. (Courtesy of Richard and Tuve Kittel.)

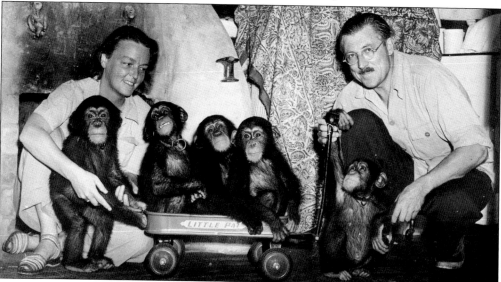

Alma Goebel Heil's 2004 article in the *Ventura County Star* mentioned a story her mother told. Alma wrote that Curly Martin, the fire chief for the area, was the only man their pet parrot, Polly, liked. One day while Martin was visiting, the parrot perched on his Stetson hat, making cute sounds and providing a happy accompaniment to their conversation. When it was time to leave, Martin politely took off his hat to say goodbye, only to find that the bird had pecked a circle around the perimeter of the hat, leaving the unsuspecting fire chief with just the crown of his hat remaining. (Courtesy of Richard and Tuve Kittel.)

In this photograph, Roy Kabat appears on the set of *Doctor Doolittle* in 1967. Roy's daughter Robin recalls actor Rex Harrison's apprehension in working with the animals, suggesting he should have been in line for an Academy Award given his warm on-screen relationship with the animals. Roy Kabat began managing Jungleland for Sid Rogell and James Ruman as early as 1957, and by 1965, Kabat and his business partner, Thurston "Tex" Scarborough, had worked out an arrangement with Louis Goebel to buy the park. (Courtesy of Robin Kabat Dickson.)

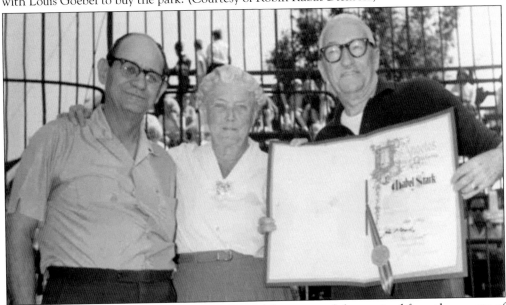

Tex Scarborough (left) joins Mabel Stark (center) for an award she received from the county of Los Angeles. Together in 1954, Scarborough and Roy Kabat each bought a quarter interest in the park. The next year, the two took on full ownership. In 1966, two maulings occurred within a two-month period. In October, Scarborough was conducting a tour inside a tiger compound. When he bent down to tie the laces of his shoe, a tiger pounced on him, attacking his leg and foot. The attack resulted in a partial amputation. (Courtesy of Robin Kabat Dickson.)

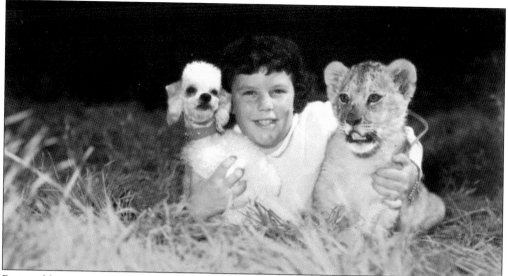

Pictured here with a lion cub and a poodle is Robin, the daughter of Roy G. Kabat, part owner of the Jungleland compound for a time. In 1977, Roy Kabat founded the nonprofit organization Dogs for the Deaf. (Courtesy of Stagecoach Inn and Conejo Valley Historical Society.)

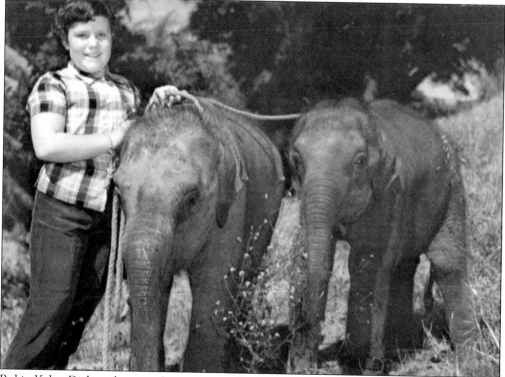

Robin Kabat Dickson became the president of her father's nonprofit organization in Oregon. She spent part of her youth at Jungleland during the 1950s and remembers that it was one of the few amusement parks around at the time. The compound's heyday was before television took over. Jungleland was the first choice for birthday parties and family outings. (Courtesy of Stagecoach Inn and Conejo Valley Historical Society.)

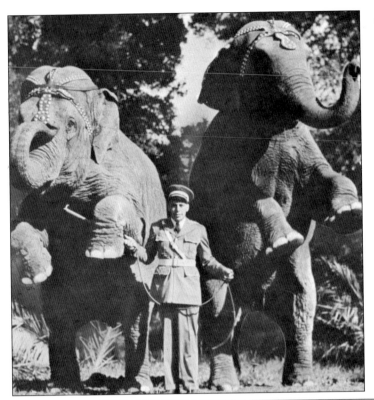

George Emerson was another animal trainer who worked on dozens of film sets and at the World Jungle Compound before and after it became Jungleland. At the age of 14, Emerson joined the Fells-Floto Circus after seeing it pull through his hometown of Worcester, Massachusetts. While he worked with horses, tigers, lions, deer, pumas, chimps, buffalo, and pythons, Emerson's elephant act became his signature performance. In addition to the Tarzan movies, Emerson worked on *The Good Earth* (1937), *The Yearling* (1946), *Quo Vadis* (1951), and his last film, *Jumbo* (1962).

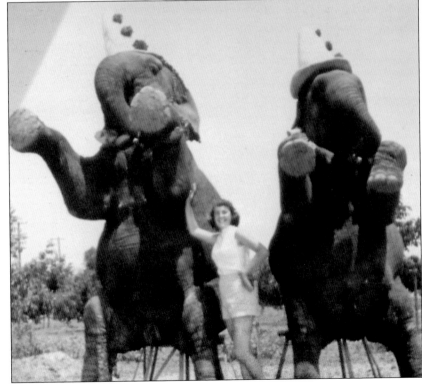

This image looks to be of Anna Muller and two of the elephants used in her act. (Courtesy of Thousand Oaks Library.)

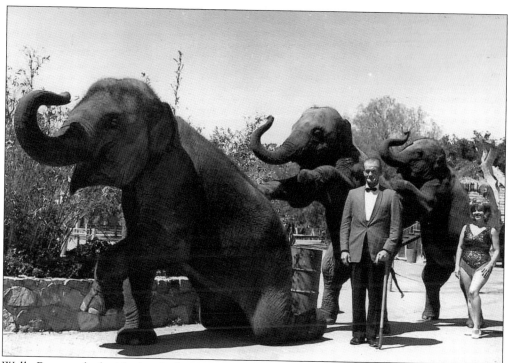

Wally Ross worked with the elephants at Jungleland, and he later managed the Pacific Ocean Park. Ross was talented in working with both animals and children. He became a second father to Roy Kabat's daughter, Robin. (Courtesy of Robin Kabat Dickson.)

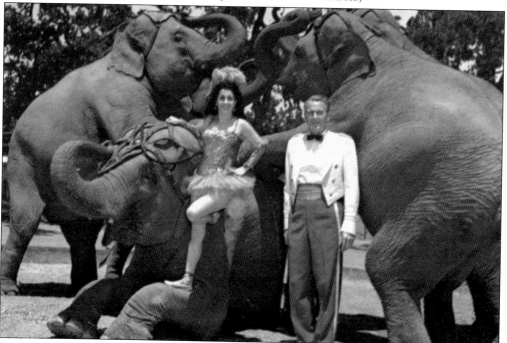

Jo and James Madison are seen with 20 tons of pachyderms from the Jungleland period (1956–1969).

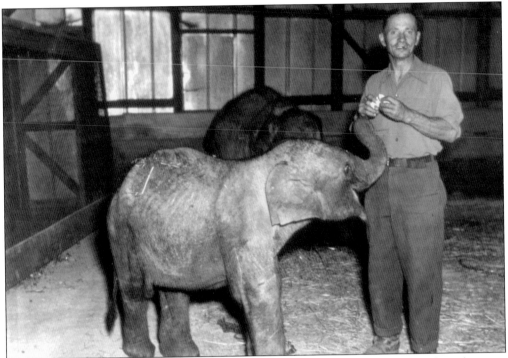

An unidentified trainer tends to a baby elephant. (Courtesy of Thousand Oaks Library.)

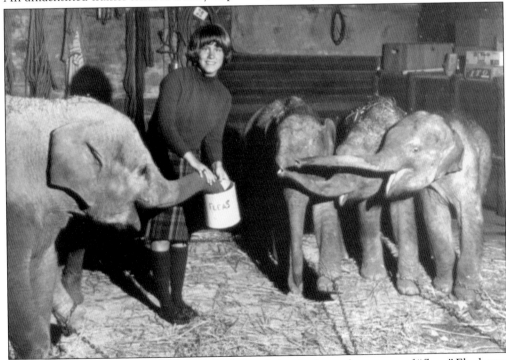

A 1960s Miss Conejo Valley contestant feeds four baby elephants from a can of "fleas." Elephants mainly eat grass and bark. An adult can weigh up to 10,000 pounds and drop 80 pounds of feces at a time. (Courtesy of Thousand Oaks Library.)

Tony Gentry trained several animals in addition to elephants. His wife, Margaret, also worked at the park. Gentry was saved one day by Bimbo the Elephant after the notoriously mean Betty (another elephant) attempted to crush him while he was trying to chain her feet. Bimbo leaned against Betty, giving Wally Ross enough time to use the bull hook to drag Gentry to safety. (Courtesy of Thousand Oaks Library.)

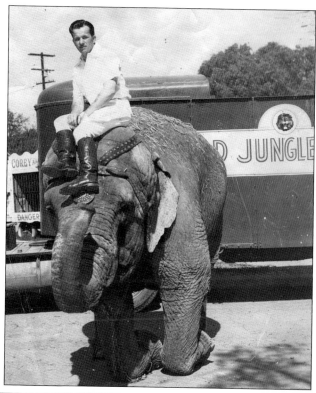

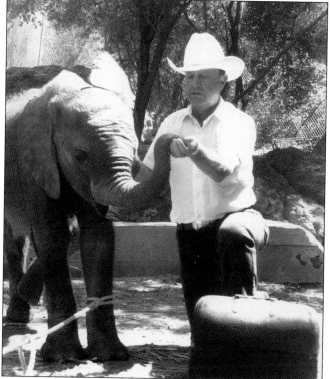

This photograph from 1959 shows Dr. Robert Miller at the Conejo Valley Veterinarian Clinic in Thousand Oaks. He served as one of the doctors for the animals at Jungleland. He went on to become a world-renowned equine behaviorist. Miller began his practice in Thousand Oaks in 1957. His book, *Yes, We Treat Aardvarks*, recounts many of his adventures while tending to animals at Jungleland and beyond. (Courtesy of Conejo Through the Lens, Thousand Oaks Library.)

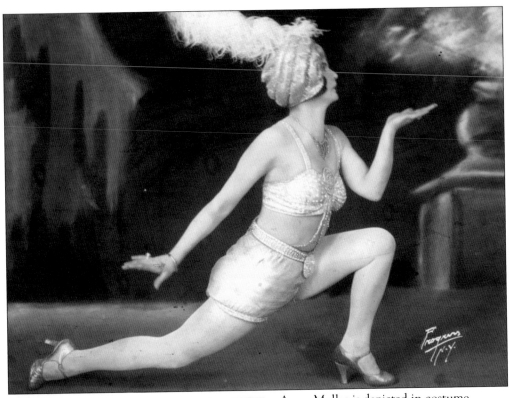

Anna Muller is depicted in costume in a picture taken before her arrival at the park. Anna and her husband, Rudy, began performing at Jungleland in 1946. (Courtesy of Thousand Oaks Library.)

Jimmy Durante poses with an elephant from the World Jungle Compound to promote his movie *Jumbo* (1962). This was the last movie that elephant trainer George Emerson worked on before he passed away. (Courtesy of Thousand Oaks Library.)

Taken prior to his arrival at the park in 1946, this photograph shows a costumed Rudy Muller. Almost four years later, on Christmas Eve day, Muller was witness to a brutal mauling. Mae Kovar Schafer, 42, was attempting to train Sultan, an adult lion, when he sprang upon Schafer, grabbing her by the throat with his sharp teeth and severing her spine. Muller ran into the arena with a pitchfork and eight-foot iron pipe. He stabbed the lion in the side and clubbed it on the head before he was able to drag the lifeless body out of the arena. (Courtesy of Thousand Oaks Library.)

Here, Rudy Muller plays the role of maharaja with his wife, Anna, lying on the ground under an elephant's foot. (Courtesy of Thousand Oaks Library.)

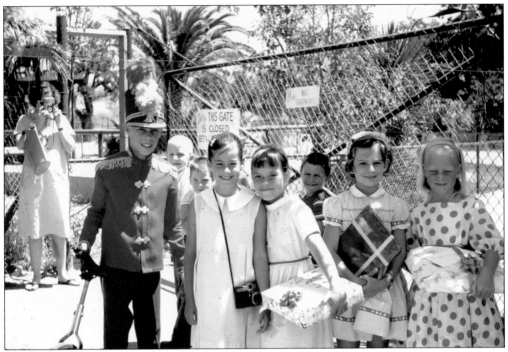

Randy Runyon, the sentry, poses next to Debbie Birenbaum (with camera) and birthday guests in 1965. (Courtesy of Conejo Through the Lens, Thousand Oaks Library.)

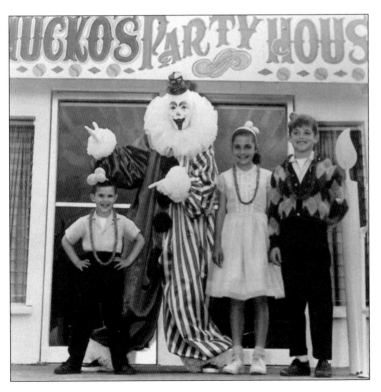

Chucko the Clown was a popular television show on ABC from 1955 to 1962. Paul Runyon played Chucko. After the show ended, Runyon had a two-year stint on channel 11 from 1963 through 1964. Roy Kabat knew Runyon from the days when Kabat was producer for *Chucko*. Kabat brought Chucko to Jungleland to host birthday parties for kids. (Courtesy of Robin Kabat Dickson.)

Three

THE ANIMALS

Over the years, many chimpanzees used by the motion picture industry were trained at the World Jungle Compound and, later, Jungleland. Tamba was one of the early stars from the Tarzan movies. When Tamba retired, a chimpanzee named Peggy took over for him. This photograph is entitled, "Chim—Man from Mars." (Courtesy of Richard and Tuve Kittel.)

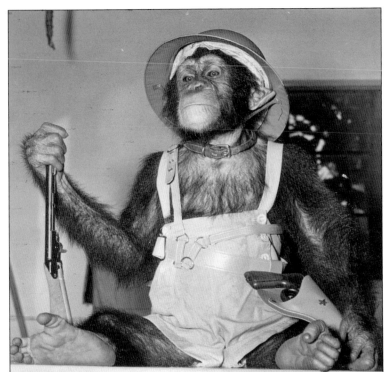

Two of the park's most popular chimpanzees were Neil and Emil. Here, Neil is shown, begging the question: "Why would anyone dress up a chimpanzee?". (Courtesy of Richard and Tuve Kittel.)

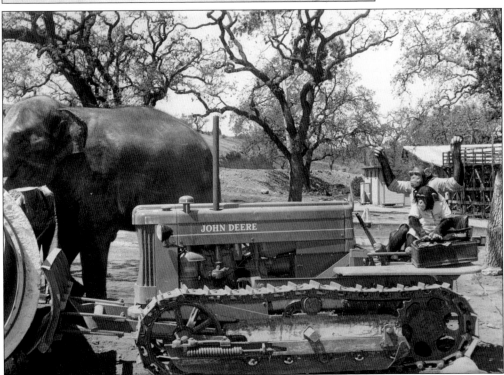

Here, Neil and Emil are shown debating about who will take control of the John Deere tractor. (Courtesy of Stagecoach Inn and Conejo Valley Historical Society.)

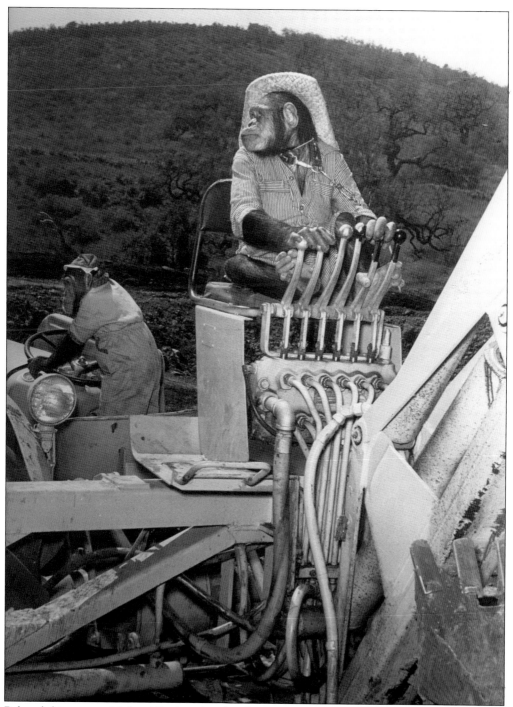

Beloved chimpanzees Neil and Emil try their hand at operating heavy equipment. This photograph was taken by Ed Lawrence. (Courtesy of Stagecoach Inn and Conejo Valley Historical Society.)

Little Chim hams it up for the cameras. Little Chim spent many hours in front of the camera, appearing most notably in the Tarzan movies. Multiple chimpanzees played Tarzan's pal, Cheetah, in the films. The original Cheetah died in the 1930s.

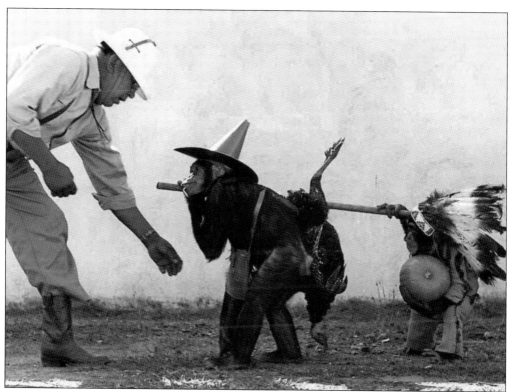

Henry Tyndall was a Native American from the Cherokee Nation. He worked at the park for over 20 years and was in charge of training chimpanzees for movies. (Courtesy of Robin Kabat Dickson.)

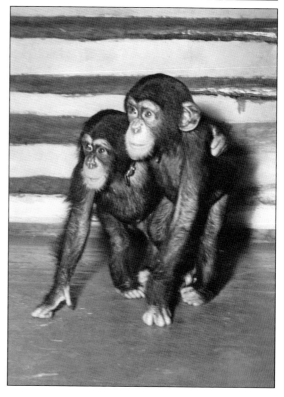

Touring the Jungleland compound was an exciting and popular destination for school field trips. Bill Parry, who attended Kamala Elementary School in Oxnard, California, recalls that during a class visit to Jungleland, a chimpanzee once dashed in front of the group of students with an anxious trainer following close behind. (Courtesy of Richard and Tuve Kittel.)

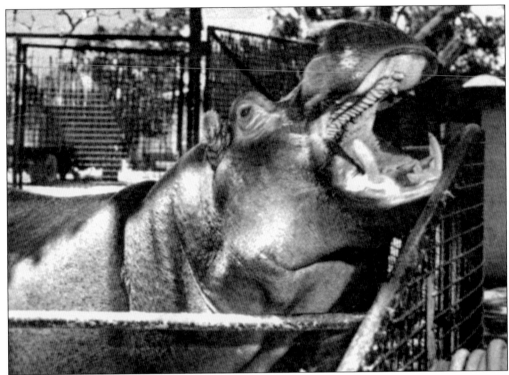

In this photograph, a hippopotamus known as Sammy the Hippo calls out for food.

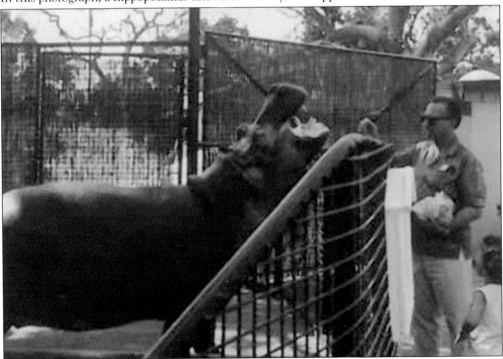

Here, Roy Kabat obliges by offering Sammy a snack. In addition to being part owner of Jungleland, Kabat worked in television, film, and the circus. (Courtesy of Robin Kabat Dickson.)

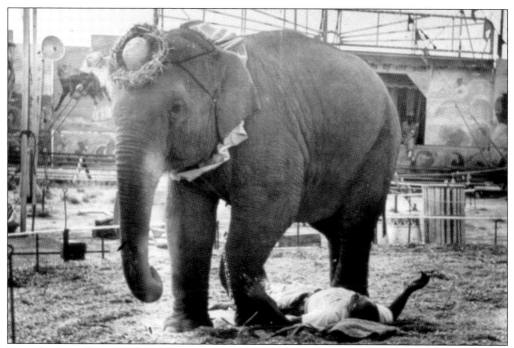

In addition to loaning the elephants out to movie studios, there were many occasions when the elephants were used as animal tow trucks, moving obstructions or mud-bound vehicles in the days before asphalt. Here is an elephant from a daily performance. (Courtesy of Thousand Oaks Library.)

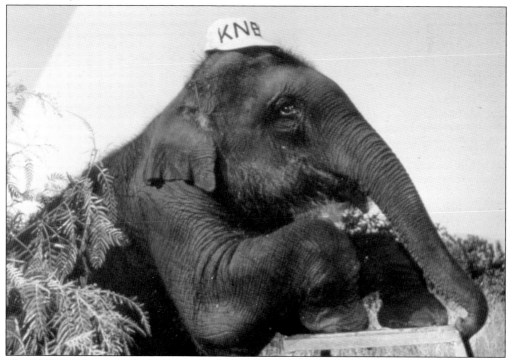

The KNBC Television elephant gets ready to take a bow. (Courtesy of Thousand Oaks Library.)

In this photograph taken in 1950, Anna Muller is shown practicing her multi-animal show. (Courtesy of Thousand Oaks Library.)

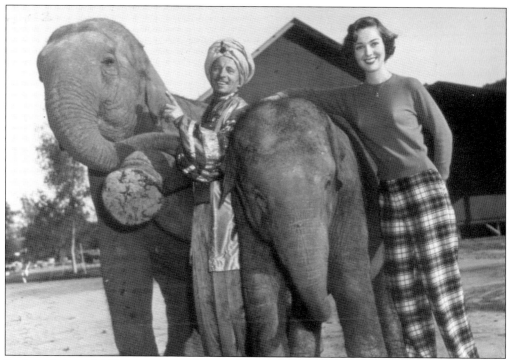

Rudy and Anna Muller are seen with two of their elephants at the World Jungle Compound in 1950. (Courtesy of Thousand Oaks Library.)

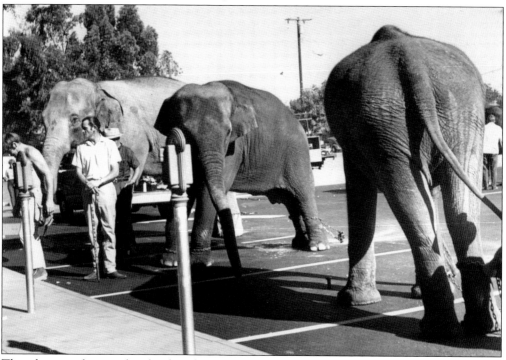

This photograph was taken by the *Thousand Oaks News Chronicle* in 1968 and shows elephants from Jungleland that were used for a car commercial. (Courtesy of Thousand Oaks Library.)

Jungleland's llamas were located with the kangaroos and amid the bison, camels, water buffaloes, and deer. Trained for several years by Earl LeGrand, Pancho was one of the park's most popular llamas. Llamas are native to South America and have been used for centuries as pack animals. One difficulty in working with llamas is their tendency to spit green, foul-smelling, digestive bile when irritated. The spitting behavior is rarely directed at humans, but it is one concern in working with llamas.

Jungleland also had giraffes. Henry the Giraffe was a featured animal in the advertisements. In this picture, it is difficult to tell which giraffe is Henry, as the two animals were said to have looked very similar to one another. (Courtesy of Thousand Oaks Library.)

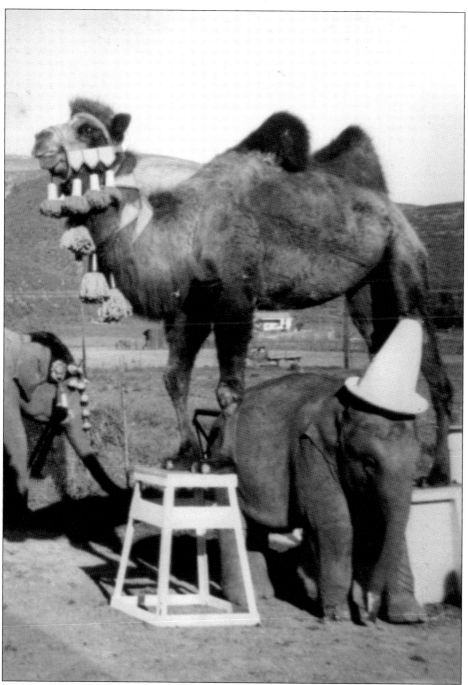

Camels from the park were used is several movies, including *King Richard and the Crusaders* (1954), starring George Sanders, Rex Harrison, and Virginia Mayo. The movie was based on Sir Walter Scott's 1825 novel, *The Talisman*. The camel used in the movie was named Adele. (Courtesy of Thousand Oaks Library.)

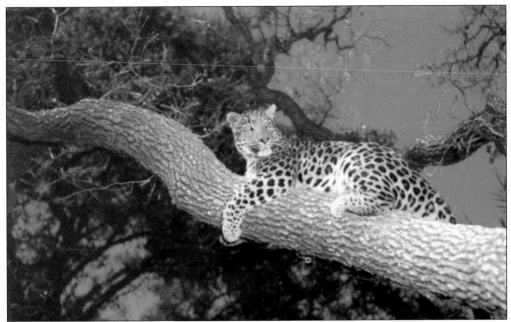

Rajah was a leopard from India and was advertised as the only trained leopard in the world to be used in motion pictures. He was trained by Ada Smieya.

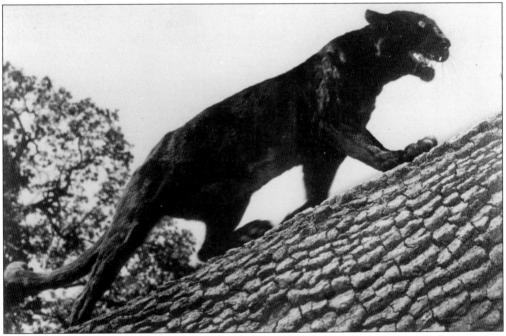

A black panther is a black variant of a cougar, leopard, or jaguar. Pictured here is Dynamite, a popular attraction at Jungleland, even before he escaped into the suburbs of the Conejo Valley in 1963. The *Los Angeles Herald-Examiner* blasted the story with this front-page headline: "Wild Panther Loose near Thousand Oaks—Armed Posse in Hunt." Dynamite briefly made it to the wild, and stories of hearing it roar grew with the tract housing that followed. (Courtesy of Thousand Oaks Library.)

On average, the high-wire act took over a year to teach to the lions. Ada Smieya was able to perfect the act within months. (Courtesy of Richard and Tuve Kittel.)

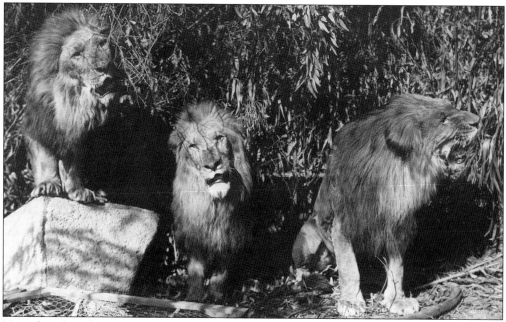

Here, three lions ham it up for the cameras. The lions were the most constant attraction throughout the 40 years of the animal compound. (Courtesy of Richard and Tuve Kittel.)

Among the featured water buffalo was Pappy. Richard Walker tended to these animals for many years. Water buffalo can be found in Africa, Australia, and America, but the vast majority is native to Asia. They are herbivores and spend the majority of their time in or near water, mud, or swamps.

Dynamite was said to be the only black panther to work on open sets with people.

In July 1950, Louis Goebel purchased 19 camels from Australia. In addition to being featured in films like *King Richard and the Crusaders* (1954) and *The Greatest Story Ever Told* (1965), these camels were also used in races against each other. The annual parade that was part of Conejo Valley Days featured camel races. (Courtesy of Thousand Oaks Library.)

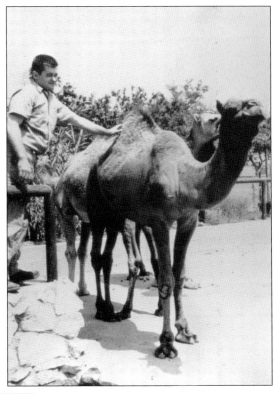

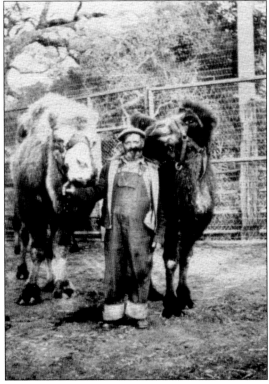

Shown here, Walter Northrup was one of the early trainers from the days of Goebel's Lion Farm. Many of the trainers over the years received their start with the circus. For several, the circus was a ticket out of town. Work at Goebel's Lion Farm and similar establishments provided the opportunity to settle down after years on the road. (Courtesy of Thousand Oaks Library.)

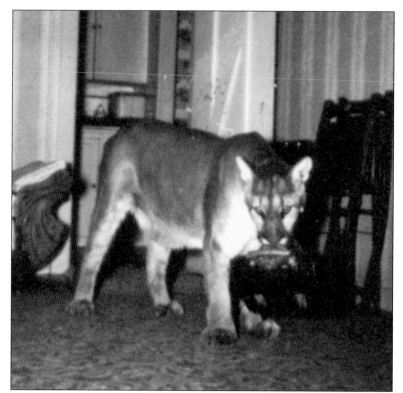

Many of the trainers from Jungleland kept wild animals as pets at their homes. In this picture at the Koontz residence, a cougar slinks across the living room as if he pays rent. (Courtesy of Thousand Oaks Library.)

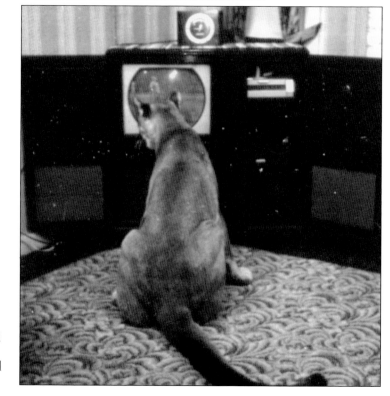

Not only new to people in the 1950s, television also seemed to interest this cougar photographed in the Koontz residence. Melvin Koontz worked with all types of animals but specialized in "rassling" cats. (Courtesy of Thousand Oaks Library.)

Four

EPHEMERA

Louis Goebel spent his life importing and exporting animals from around the world. He maintained his export business even after Jungleland closed in 1969. He supplied the rhesus monkeys used to develop the vaccine for polio. (Courtesy of Thousand Oaks Library.)

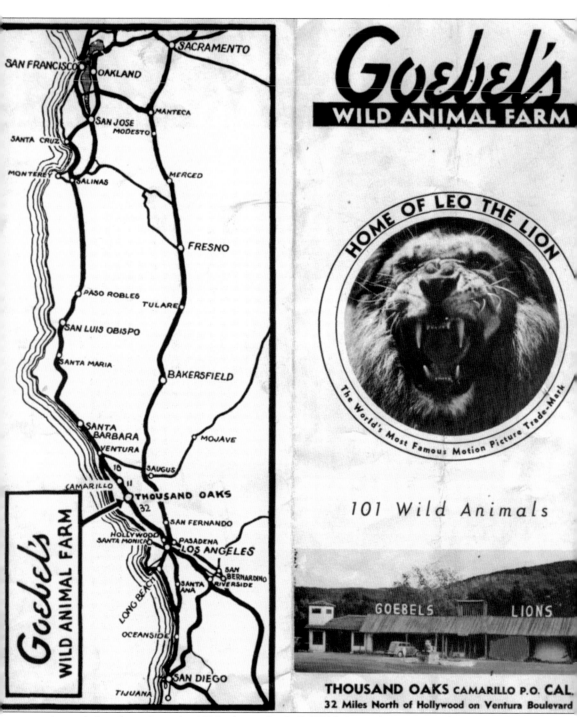

An early brochure from the 1930s shows Goebel's Wild Animal Farm. Leo the Lion is featured on the cover, and at the time, the park featured a modest collection of 101 animals. (Courtesy of Stagecoach Inn and Conejo Valley Historical Society.)

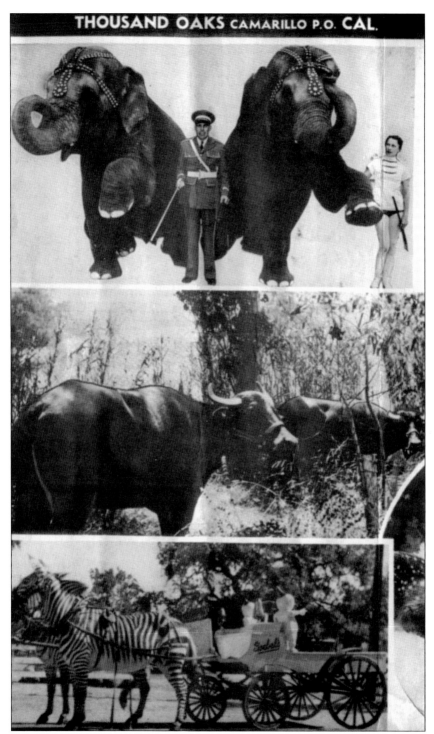

THOUSAND OAKS CAMARILLO P.O. CAL.

This portion of a 1950s program shows world-famous trainer George Emerson at the top of the page, Pappy the water buffalo in the middle, and a zebra coach on the bottom. (Courtesy of Richard and Tuve Kittel.)

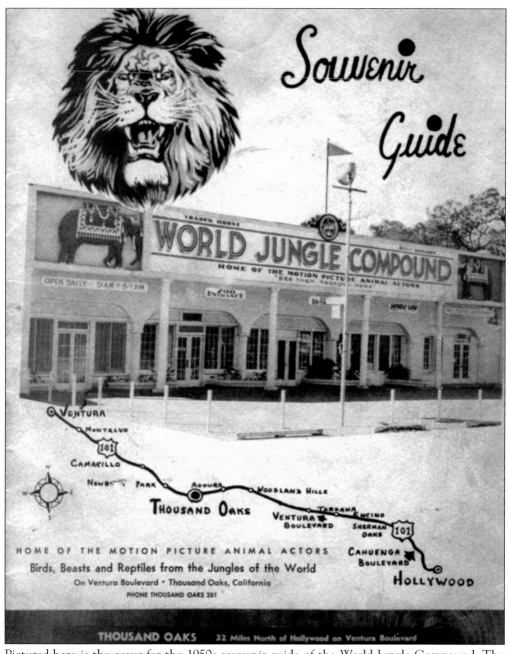

Pictured here is the cover for the 1950s souvenir guide of the World Jungle Compound. The guide describes the compound as "Home of the Motion Picture Animal Actors—Birds, Beasts and Reptiles from the Jungles of the World." (Courtesy of Stagecoach Inn and Conejo Valley Historical Society.)

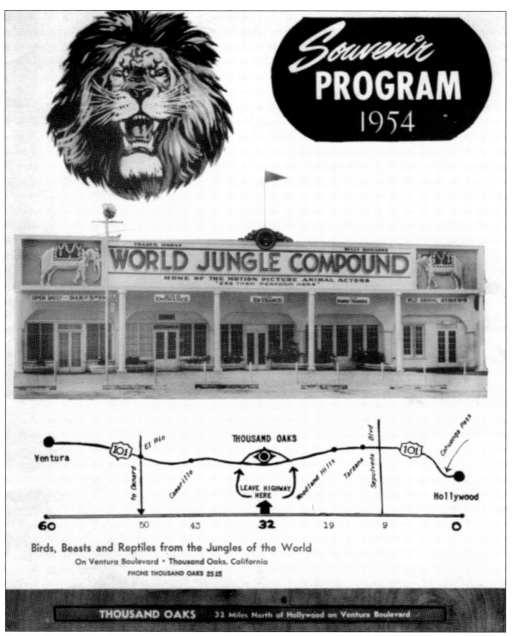

Pictured here is another souvenir guide cover. This program is from 1954. Within a year, Disneyland would open, and the stakes would be raised. New owners would have to make many improvements to the park to compete for the future.

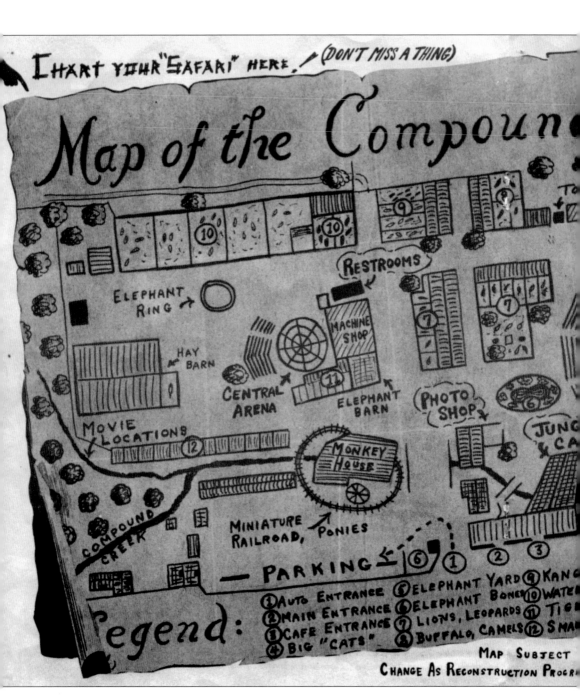

Chart your "Safari" here! (DON'T MISS A THING)

Map of the Compound

RESTROOMS

ELEPHANT RING →

HAY BARN

MACHINE SHOP

MOVIE LOCATIONS →

CENTRAL ARENA

ELEPHANT BARN

PHOTO SHOP

JUNGLE CA

MONKEY HOUSE

MINIATURE RAILROAD, PONIES

COMPOUND CREEK

— PARKING ↙

Legend:

① Auto Entrance ⑤ Elephant Yard ⑨ Kang
② Main Entrance ⑥ Elephant Bones ⑩ Water
③ Cafe Entrance ⑦ Lions, Leopards ⑪ Tig
④ Big "Cats" ⑧ Buffalo, Camels ⑫ Sma

MAP SUBJECT
CHANGE AS RECONSTRUCTION PROGR

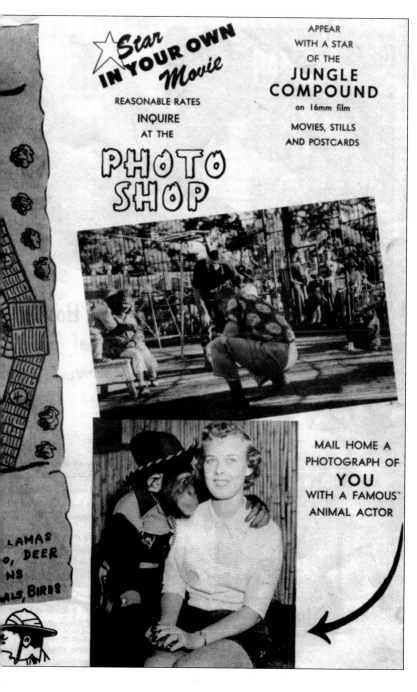

Taken from a 1950s brochure of the World Jungle Compound, the map features the elephant ring, the monkey house, the miniature railroad, and the photograph shop where patrons could choose between stills, postcards, or starring in their own 16-mm film reel with the animals. Also a part of the compound at this time was the Jungle Café, a big-cat area, and the elephant yard. Other large animals included lions, leopards, buffaloes, camels, kangaroos, llamas, deer, tigers, and lions. The park also featured smaller animals like birds and turtles.

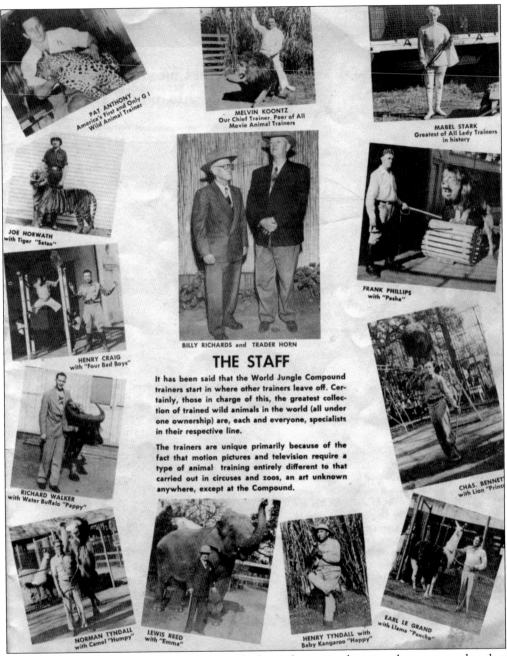

PAT ANTHONY
America's First and Only G I
Wild Animal Trainer

MELVIN KOONTZ
Our Chief Trainer. Peer of All
Movie Animal Trainers

MABEL STARK
Greatest of All Lady Trainers
in history

JOE HORWATH
with Tiger "Satan"

FRANK PHILLIPS
with "Pasha"

HENRY CRAIG
with "Four Bad Boys"

BILLY RICHARDS and TRADER HORN

THE STAFF

It has been said that the World Jungle Compound trainers start in where other trainers leave off. Certainly, those in charge of this, the greatest collection of trained wild animals in the world (all under one ownership) are, each and everyone, specialists in their respective line.

The trainers are unique primarily because of the fact that motion pictures and television require a type of animal training entirely different to that carried out in circuses and zoos, an art unknown anywhere, except at the Compound.

CHAS. BENNETT
with Lion "Prince"

RICHARD WALKER
with Water Buffalo "Pappy"

NORMAN TYNDALL
with Camel "Humpy"

LEWIS REED
with "Emma"

HENRY TYNDALL with
Baby Kangaroo "Happy"

EARL LE GRAND
with Llama "Pancho"

This page from inside the 1950s souvenir guide shows the major players at the compound at that time. Clockwise from the upper left are the following: Pat Anthony, Melvin Koontz, Mabel Stark, Capt. Frank Phillips, Charles Bennett, Earl LeGrande, Henry Tyndall, Lewis Reed, Norman Tyndall, Richard Walker, Henry Craig, and Joe Horwath. Owners Billy Richards (left) and Trader Horne appear at the center. (Courtesy of Stagecoach Inn and Conejo Valley Historical Society.)

This Jungleland advertisement features the price of admission: $1 for adults and 50¢ for children. (Courtesy of Stagecoach Inn and Conejo Valley Historical Society.)

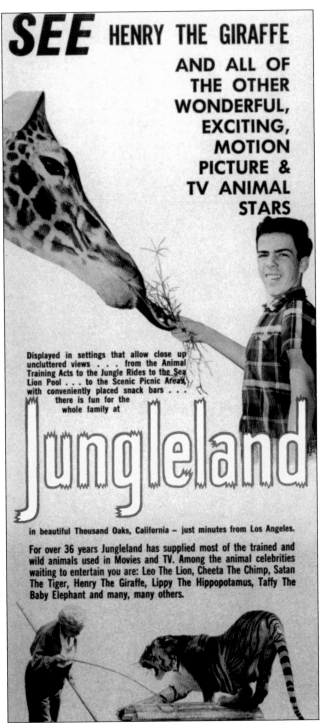

SEE HENRY THE GIRAFFE AND ALL OF THE OTHER WONDERFUL, EXCITING, MOTION PICTURE & TV ANIMAL STARS

Displayed in settings that allow close up uncluttered views . . . from the Animal Training Acts to the Jungle Rides to the Sea Lion Pool . . . to the Scenic Picnic Areas, with conveniently placed snack bars . . . there is fun for the whole family at

Jungleland

in beautiful Thousand Oaks, California – just minutes from Los Angeles.

For over 36 years Jungleland has supplied most of the trained and wild animals used in Movies and TV. Among the animal celebrities waiting to entertain you are: Leo The Lion, Cheeta The Chimp, Satan The Tiger, Henry The Giraffe, Lippy The Hippopotamus, Taffy The Baby Elephant and many, many others.

One of the rare opportunities Jungleland offered was an unobstructed, up close view of the animals at the petting zoo—something that is impossible to find in more litigious present times. Monkey Island was a favorite for visitors. As one visitor recalls, "The monkeys never failed to do something memorable," referring to them swinging from a limb or throwing something at the crowd.

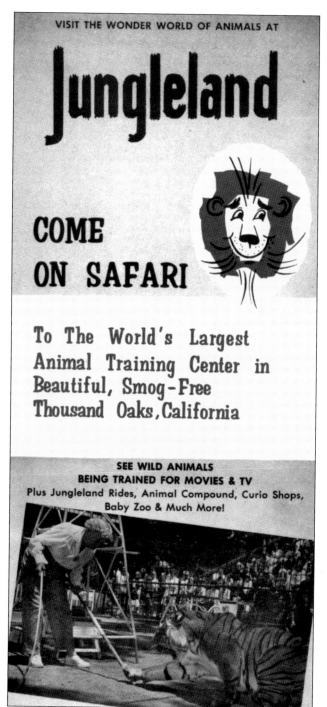

This brochure from the 1960s advertised Jungleland as "The World's Largest Animal Training Center" and noted that the park is located in "Smog-Free" Thousand Oaks, California, rather than in Los Angeles, which was already known for its smog at that time. The park personified the animals by giving them names such as Henry the Giraffe, Taffy the Baby Elephant, and Satan the Tiger.

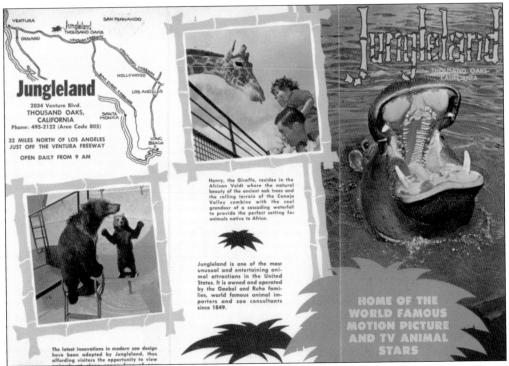

This brochure dates back to the mid-1960s.

In addition to animals that appeared in motion pictures, the park offered an up close and hands-on view of all the animals.

Wild animal shows at Jungleland were performed from 2:00 p.m. to 3:00 p.m. on weekdays and from 1:30 p.m. to 4:30 p.m. on Sundays and holidays. (Courtesy of Stagecoach Inn and Conejo Valley Historical Society.)

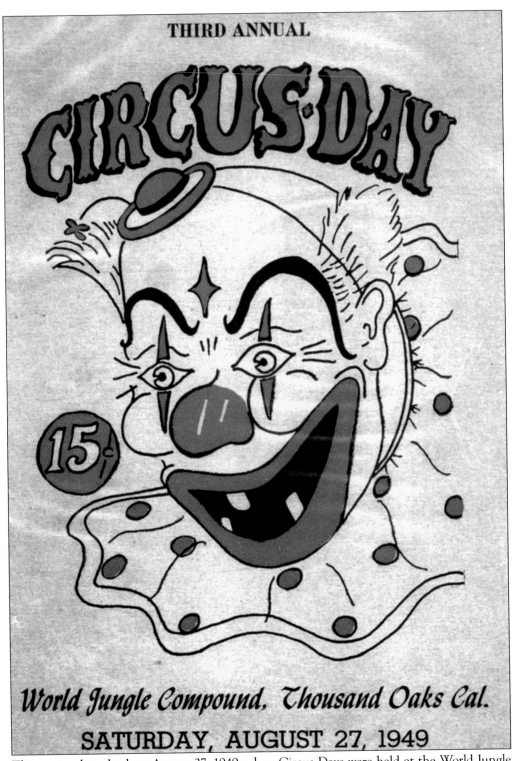

THIRD ANNUAL

Circus·Day

15¢

World Jungle Compound, Thousand Oaks Cal.

SATURDAY, AUGUST 27, 1949

This poster dates back to August 27, 1949, when Circus Days were held at the World Jungle Compound. (Courtesy of Stagecoach Inn and Conejo Valley Historical Society.)

Pictured here is a 1960s flyer advertising the 6th annual Conejo Valley Days event. In 2010, Conejo Valley Days held its 54th annual celebration.

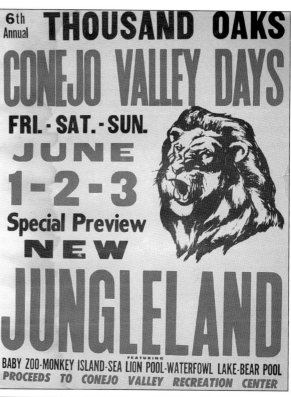

In 1957, a parade was added to Conejo Valley Days. Mabel Stark was the inaugural grand marshal for the event. Others who have served as grand marshal include Jackie the Lion, Joel McCrea, Walter Brennan, Slim Pickens, and Strother Martin. This entrant represented the Stagg Shop for Men. (Courtesy of Thousand Oaks Library.)

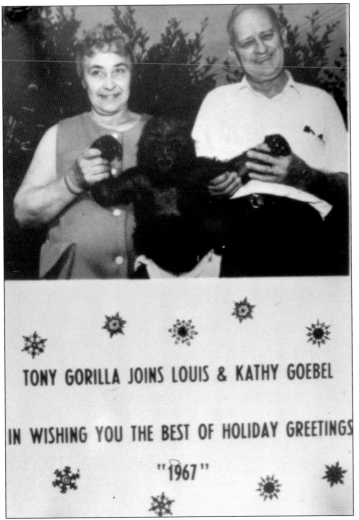

Louis and Kathleen Goebel always included one of their pets in their Christmas postcard. This greeting from 1967 includes their baby, Tony Gorilla. (Courtesy of Thousand Oaks Library.)

TONY GORILLA JOINS LOUIS & KATHY GOEBEL

IN WISHING YOU THE BEST OF HOLIDAY GREETINGS

"1967"

The heading for Louis Goebel's letterhead from 1976 included son Eugene's name and a post office box in Tehachapi, which was located in Kern County, California. (Courtesy of Thousand Oaks Library.)

Five

HOLLYWOOD

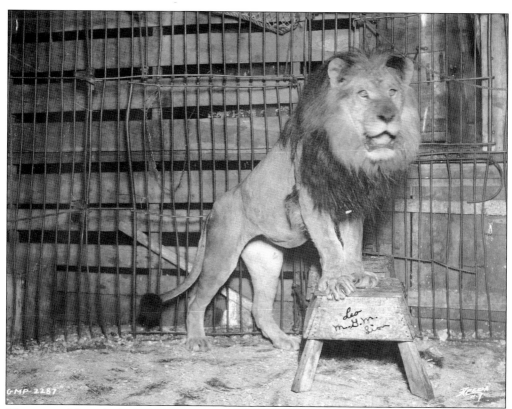

The original Leo the Lion was named Slats. He was one of five Leos used as the MGM motion picture logo. He was trained by Volney Phifer, and for a time, he stayed at Gay's Lion Farm before moving to Goebel's Lion Farm. The original Leo passed away at the age of 23 and was buried at Phifer's estate in New Jersey. This picture is dated 1928. (Courtesy of Richard and Tuve Kittel.)

Mabel Stark doubled for Mae West in her 1933 movie *I'm No Angel*. The movie about a female lion tamer and dancer in search of her dark-haired prince also featured Cary Grant. Future Jungleland trainers Melvin Koontz and Capt. Frank Phillips also worked on the set of the movie. Koontz takes credit for doubling for West in a scene that called for her to put her head inside the lion's mouth. West wrote the screenplay, and her inclusion of the lion-taming scenes harken back to her childhood days of visiting Coney Island to see the famous Bostock's Lions.

While Frank Buck was not directly associated with Jungleland, there are many peripheral connections to mention. Buck was an animal hunter and collector, actor, writer, and producer. His book *Bring 'Em Back Alive* sparked interest in wild animal adventures. He brought his collection of wild animals to the world's fair in 1939, naming the display Frank Buck's Jungleland. Buck owned an orangutan named Jiggs, who was featured in some of the Tarzan movies. This photograph was signed to Siva Phillips, wife of Capt. Frank Phillips. (Courtesy of Richard and Tuve Kittel.)

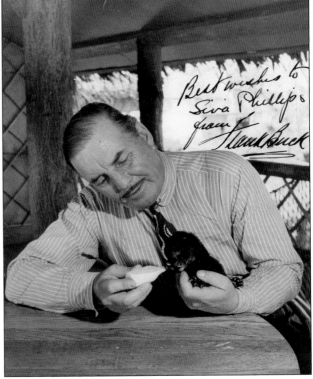

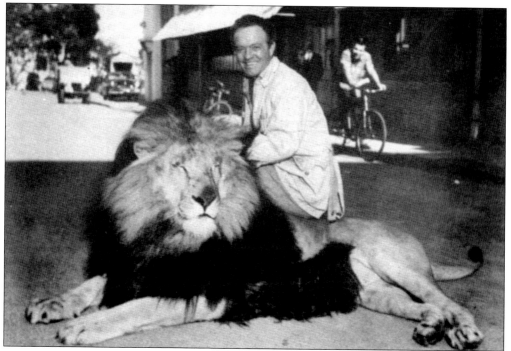

Van Heflin sits on his costar, the lion known as Jackie II. Filmed on the Universal-International Pictures set, the movie *Tanganyika* was released in 1954 and also starred Ruth Roman and Howard Duff. Other animals used in the film were Killer Charlie (a leopard), Neil (chimpanzee), and an elephant named Tusko.

The 1950 comedy *Mad Wednesday* featured Harold Lloyd, Frances Ramsden, and Jackie II the lion. Originally filmed as *The Sin of Harold Diddlebock* in 1947, the film was pulled from distribution by producer Howard Hughes, who had several scenes reshot and edited for the renamed movie. For former silent-screen star Lloyd, the delay in release quelled the momentum of his return to film.

Clark Gable had many connections with Ventura County, including frequenting the Colonial House in Oxnard, golfing at Saticoy Country Club, and visiting Goebel's Lion Farm. Here, Gable holds two lion cubs. Ironically, rumors suggested that Gable's last name was, at one time, spelled Goebel. However, his father's name was Gable, and the spelling went back five generations. (Courtesy of Thousand Oaks Library.)

Laurence Harvey checks with Adele the camel during a scene from the 1954 movie *King Richard and the Crusaders*. The film was shot at Iverson Ranch in Chatsworth, California, as well as Ventura, California, and Yuma, Arizona. Despite an all-star cast that also included Rex Harrison, Virginia Mayo, George Sanders, and several other animals from the World Jungle Compound, the movie was roundly panned. (Courtesy of Richard and Tuve Kittel.)

Johnny Weissmuller poses with a lion from Jungleland. Weissmuller was in constant contact with the World Jungle Compound, whether filming a scene for one of his movies or working with the animals supplied for the films. Weissmuller was an Olympic swimming champion and world-record holder of 67 medals. From 1932 through 1949, he made nearly 20 Tarzan films. Many of the early Tarzan movies were shot in the Lake Sherwood area.

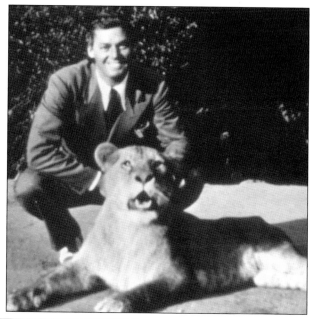

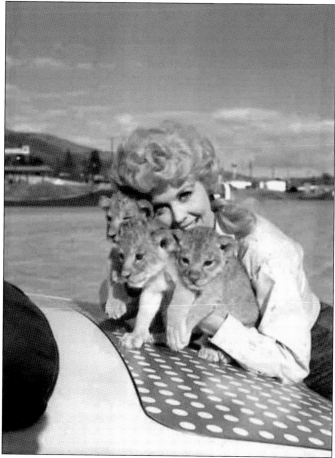

Donna Douglas starred in the 1960s comedy *The Beverly Hillbillies*. Jungleland provided many of the animals for the show. Here, Douglas caresses three lion cubs at Jungleland. Chimpanzees, deer, possums, goats, a raccoon, a sea lion, and a bobcat were among the other critters Douglas befriended on the show. (Courtesy of Robin Kabat Dickson.)

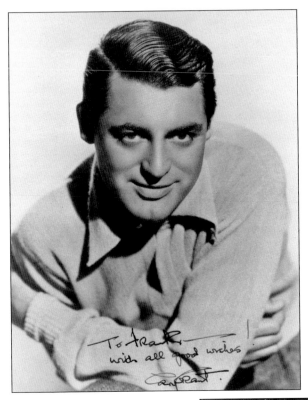

Cary Grant worked with Capt. Frank Phillips on the set of *I'm No Angel* (1933) and was kind enough to give Frank an autographed photograph. The movie also featured Mae West, and the premise of the film included a one-ring circus and sideshow carnival. Frank Phillips was on hand when West rode an elephant into the ring. (Courtesy of Richard and Tuve Kittel.)

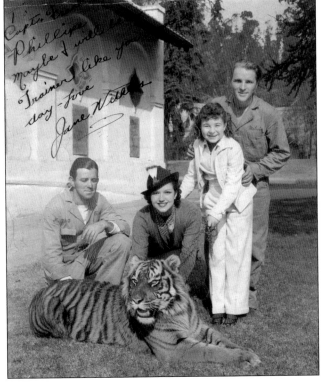

Jane Withers, the child actress, suggests the possibility that she may "become a trainer" like Capt. Frank Phillips in her signed photograph to Phillips. Phillips is on the left, and Melvin Koontz is on the right, behind Withers and an unidentified woman. Withers made 47 films as a child star. She retired in 1947 but returned in 1956 and went on to become a very recognizable character. (Courtesy of Richard and Tuve Kittel.)

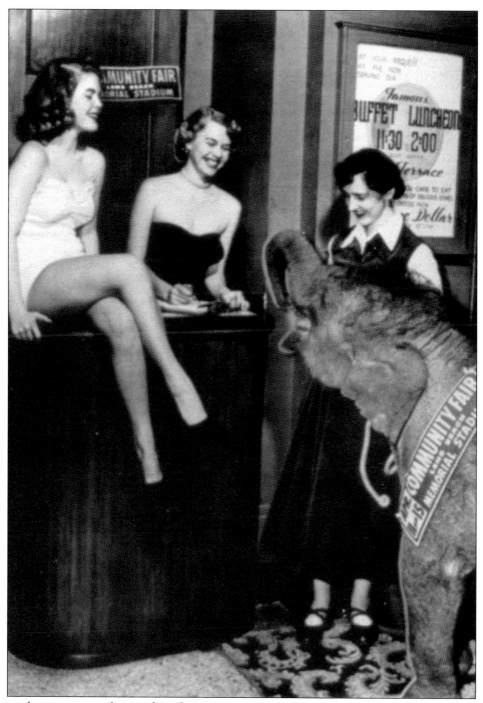

Animals were constantly rented out for movies, commercials, and events. Here, an elephant from Goebel's Wild Animal Farm is used to help promote the Long Beach Community Fair of 1940. (Courtesy of Thousand Oaks Library.)

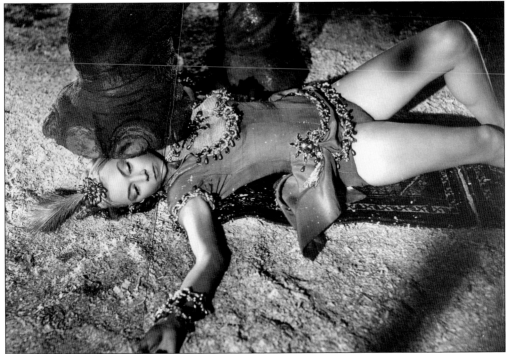

This scene from *The Greatest Show on Earth* (1952) features Gloria Grahame and Minyak the Elephant. Many trainers from World Jungle Compound worked on the film.

The Robe (1953) featured camels from the World Jungle Compound. This movie was the first production released in the new film format, cinemascope, which featured a wide screen and the sales pitch, "The modern miracle you see without glasses." Parts of the film were shot at the nearby Corrigan Ranch in Simi Valley.

Former Olympic gold-medal swimmer Johnny Weissmuller and Maureen O'Sullivan starred in six Tarzan movies together, along with their chimpanzee costar who played Cheetah. Many of the scenes were filmed in the Thousand Oaks and Lake Sherwood areas. The role of Cheetah was originally assigned to a chimpanzee named Jiggs. However, multiple primates played the role over the years. A rumor arose claiming the original Cheetah was still living in a sanctuary in Palm Springs at the ripe age of 76. Further investigation proved the rumor false, showing proof that the original Cheetah passed away in 1935. The chimpanzee living in Palm Springs was born in 1960. He retired to Palm Springs from Pacific Ocean Park when it closed in 1967.

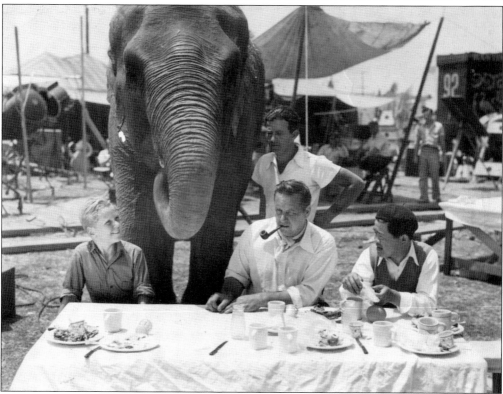

In 1935, child actor Jackie Cooper (left) starred in *O'Shaughnessy's Boy* with Wallace Beery (not pictured). Beery played the part of a lion trainer. Capt. Frank Phillips (standing) worked on the set and filled in for Beery for the cage scenes. Director Ryszard Boleslaw (center) is shown smoking a pipe, and on the far right is master cinematographer James Wong Howe, whose career stretched from 1923's *Drums of Fate* to 1975's *Funny Lady*. (Courtesy of Richard and Tuve Kittel.)

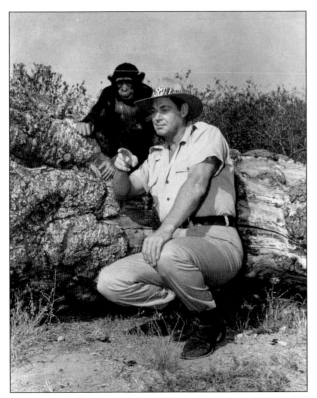

The Jungle Jim movies featured former *Tarzan* star Johnny Weissmuller and Tamba the Chimpanzee from the World Jungle Compound. Tamba died in a fire at the facility in 1951 and was replaced by Peggy, who would also maker her home in Thousand Oaks. The Jungle Jim movies gave way to the television series, which ran from 1955 to 1956. "Jungle Jim" began as a comic strip in 1934. The *Adventures of Jungle Jim* premiered November 2, 1935. A 12-part movie serial followed in 1937, and by 1948, Weissmuller was cast in a run of movies that was followed by a television series.

Irish McCalla starred as the six-foot-tall jungle girl swinging her way through the forest in the television series *Sheena, Queen of the Jungle* (1955–1956). Chimpanzees Chim and Neil from Jungleland were featured in many of the episodes. The Sheena series was also preceded by a comic strip before evolving into a show.

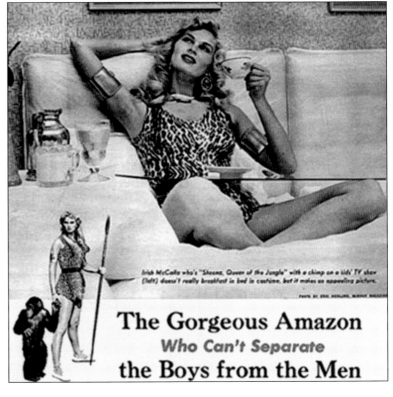

Irish McCalla who's "Sheena, Queen of the Jungle" with a chimp on a kids' TV show (left) doesn't really breakfast in bed in costume, but it makes as appealing picture.

The Gorgeous Amazon
Who Can't Separate
the Boys from the Men

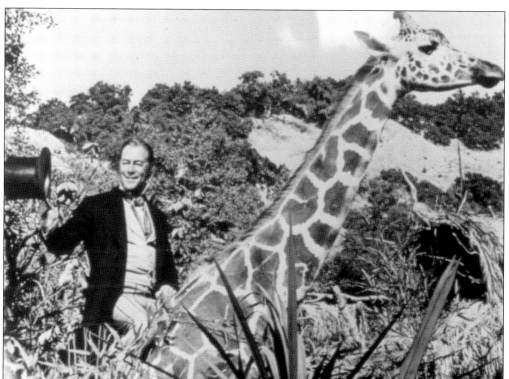

A portion of *Doctor Doolittle* was filmed at the 20th Century Fox Ranch and the Malibu Creek State Park. Many of the animals featured in the film were from Jungleland. Animal trainer Roy Kabat from Jungleland was utilized at these scene locations. (Courtesy of Thousand Oaks Library.)

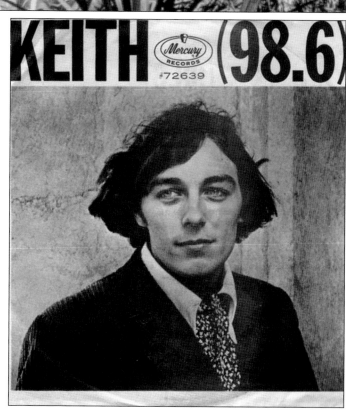

Pop artist Keith—born James Barry Keefer—taped the video for "98.6," his hit single in 1967, at Jungleland. The record climbed to number seven on the pop charts. Other songs that topped the charts in 1967 were "Happy Together" by the Turtles, "Light My Fire" by the Doors, and "All You Need is Love" by the Beatles.

Saturday, November 26, 1966, was the beginning of the end for Jungleland. Movie star Jayne Mansfield arrived at Jungleland for a photograph shoot in the Tarzan Jungle area. She was given a VIP tour by owner Roy Kabat.

Accompanying Mansfield for her photograph shoot were her children from a previous marriage, Miklos, Zoltan, and Mariska Hargitay. (In 1999, Mariska was cast as a lead in the television show *Law & Order: Special Victims Unit*, and she began her 12th season with the show in 2010.) Also joining Mansfield at the park were attorney Sam Brody, houseguest Murray Banks, his four-year-old son, and May Mann. Taking pictures for the day was photographer David Payne. After moving away from a male lion that seemed angry, the group did not realize that six-year-old Zoltan had wandered toward the lion, which was leashed with a seven-foot chain. (Courtesy of Thousand Oaks Library.)

DO NOT GO
Behind This Railing
NO EXCEPTIONS

The male lion jumped on Zoltan, knocking the boy on his stomach, and clamped his jaws around Zoltan's neck. After much struggling, Kabat pried open the lion's jaws. With blood gushing and cries of hysteria, the boy was rushed to Community Memorial Hospital in Ventura, where he underwent a six-hour surgery. The boy would go through two more surgeries before making a full recovery. But Jungleland did not recover. Mansfield hired renowned defense attorney Melvin Belli and sued the park for $1.6 million.

Donnie Fletcher was two years old when he lived across the street from the Goebel family on Pleasant Way Drive in 1942. The Goebels' pet panther was tied to a stake in their backyard when Donnie offered the big cat one of his cookies. The mighty panther took a swipe at the food and caught Donnie's throat with his claw. Two more swipes to the head followed. Young Donnie was raced to the nearest hospital (at the time, St. John's Hospital in Oxnard) and was given immediate care by Dr. E.C. Beach, who sutured the wounds across Donnie's throat, forehead, and cheek. With one eye missing, Donnie regained consciousness for a day, but his frail body fell into shock, and he died. (Courtesy of Thousand Oaks Library.)

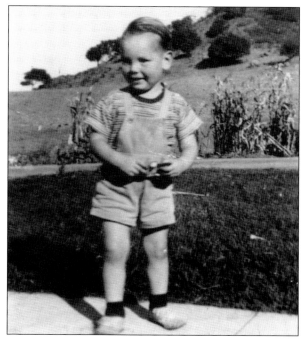

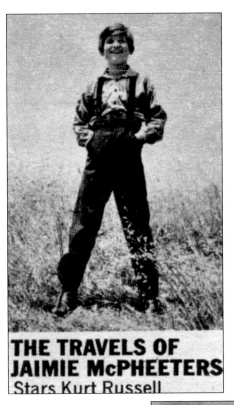

THE TRAVELS OF JAIMIE McPHEETERS
Stars Kurt Russell

Kurt Russell was a Thousand Oaks resident and frequent visitor to Jungleland. Russell began acting at age six. By 1963, Russell was featured in his first film, *It Happened at the World's Fair*. He also appeared in the television series *The Travels of Jaimie McPheeters* (1963–1964). Russell graduated from Thousand Oaks High School in 1969, along with classmate Michael Richards, who played Kramer in *Seinfeld* (1989–1998). Russell's parents were also in the entertainment field. His mother, Louise Crone, was a dancer, and his father, Bing Russell, was a character actor. Bing played Deputy Clem Foster on *Bonanza*, which was filmed in Thousand Oaks.

The sign for Tamba at the World Jungle Compound read: "Tamba, the Most Publicized Chimpanzee in the World. Does Everything but Talk." Tamba starred in several of the Jungle Jim films with Johnny Weissmuller. His last film was *Bedtime for Bonzo* with the future president of the United States, Ronald Reagan. On the eve of the premiere, Tamba died of smoke inhalation from a fire at a Quonset hut at the World Jungle Compound in 1951. Tamba was replaced by Peggy, who took on the Tamba stage name.

Six

POST-JUNGLE

The missing facade of Jungleland in 1970 illustrates the sad end to one of Southern California's earliest amusement parks, and with it, the end to Ventura County's immediate connection to Hollywood. Jungleland was in competition with the proliferating amusement parks in Southern California, including Disneyland, Knotts Berry Farm, Universal Studios, Corriganville/Hopetown, and others. (Courtesy of Stagecoach Inn and Conejo Valley Historical Society.)

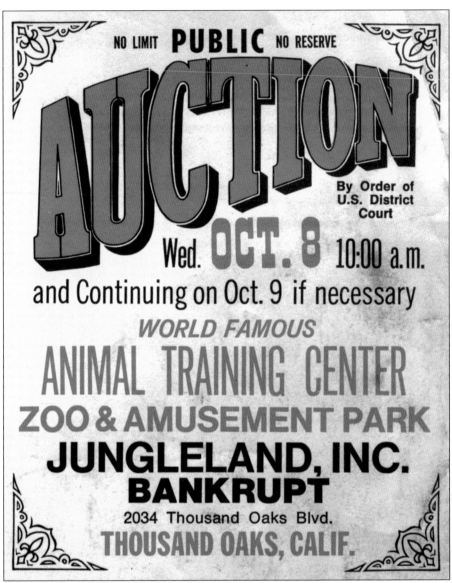

After several attempts to keep the park afloat during its dying days, management decided that the face-lift needed to compete with the newer and more polished amusement parks would cost too much money. In May 1969, Louis Goebel took action to close Jungleland after owners Roy Kabat and Tex Scarborough entered voluntary bankruptcy. An auction was held on-site—one last performance. More than 1,800 animals, trucks, trailers, wagons, maintenance and concession equipment, office furniture and supplies, animal cages, plants, and the miniature train were all auctioned off. A hippopotamus sold for $450, one tiger fetched $750, a tortoise sold for $2,500, and an orangutan and its mate were bought for $10,000.

Despite no trespassing signs prominently posted on the remaining 20 acres, the site fell victim to looters, loiterers, homesteaders, and weekend parties.

For the teenagers of Thousand Oaks, the unpatrolled wasteland was a perfect spot to gather. Several park parties with live music took place. Two former members of the rock band Steppenwolf were known to perform for the locals.

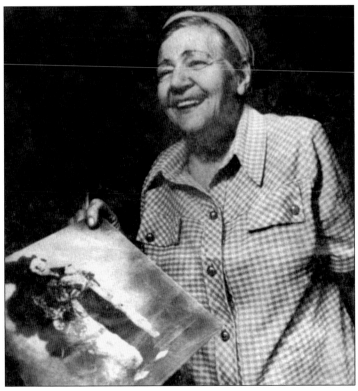

Asta Goudsmit (pictured) and her husband, Emanuel Natty, were longtime performers at Jungleland. Natty had a dog and clown act, and his family's European roots in entertainment go back to the fourth century. After the park closed in 1969, the couple took their act and 16-foot trailer to another site. But they, along with dozens of other past performers, always returned to the Goebel property to park the trailer behind the big barn. Without a restroom and with only improvised electrical connections, the Goudsmits were forced to leave in 1981 when the Goebels sold the property.

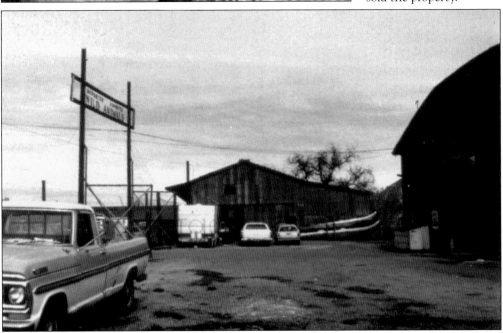

Louis Goebel retained the right to the land after the park closed. He kept the barns in use for several years and charged a nominal fee to the performers and trainers who needed a place to park their trailers. The Goudsmits paid $60 a month until Goebel told them to keep the rent. He "made enough money," reported Asta Goudsmit. (Courtesy of Thousand Oaks Library.)

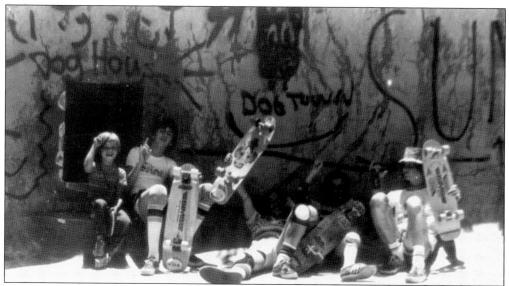

Today, cities offer skate parks. Back in the 1970s, abandoned pools became a haven for skaters from Southern California. In this photograph from 1975, Jeff "Scott" Donovan (far right) and friends take a break from skating the seal pool, which they had dubbed the "Blue Bowl." (Courtesy of Jeff Donovan of junglelandskates.com.)

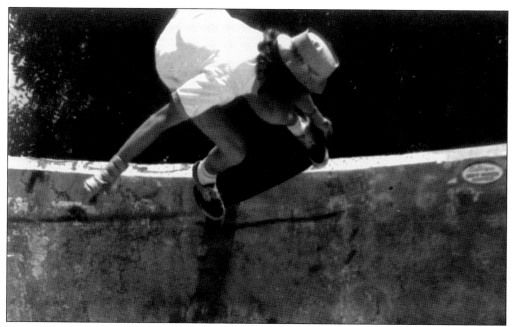

Here, Jeff Donovan demonstrates a backside nose grab. The alligator, hippo, and seal pools offered different vertical challenges. This picture shows Donovan making his way to the top of the Blue Bowl, formerly the seal pond. Not only was this the most challenging bowl to ride, but it had the most debris to clear out. (Courtesy of Jeff Donovan of junglelandskates.com.)

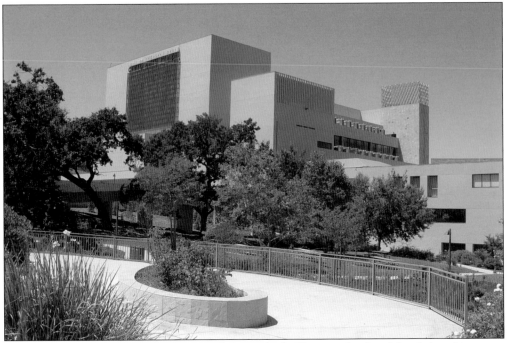

In 1994, the Thousand Oaks Civic Arts Plaza was built 25 years after Jungleland closed its gates. Located on the same site as the park, the facility cost $63.8 million to build. It was designed by Antoine Predrock in the postmodern and modern architecture styles.

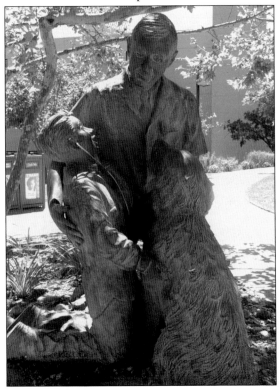

In addition to a memorial and plaque commemorating Jungleland at the Civic Arts Plaza near the south end of the building, a statue and plaque are featured on the grounds in honor of Robert E. Kind, entitled *A Kind Touch*. Sculpted by David L. Spellerberg, the statue depicts a gentle Dr. Kind helping a young boy and his dog. Dr. Kind dedicated 40 years to helping others, including the zoo animals. The plaque reads, "His manner was modest, his touch was gentle, and his laugh was legendary." Kind joined Dr. Robert Miller at the Conejo Valley Veterinary Clinic in 1961. An identical sculpture was dedicated to his alma mater, Kansas State University College of Veterinary Medicine.

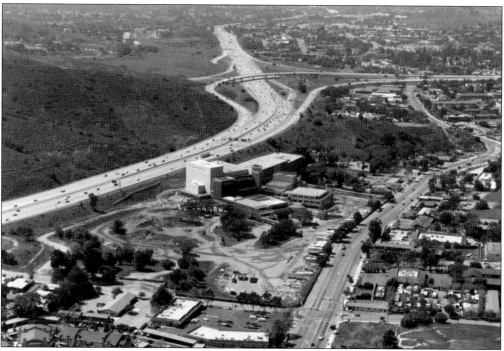

This northbound view of the Civic Arts Plaza from 1994 shows Highway 101 before it intersects with Highway 23. (Courtesy of Stagecoach Inn and Conejo Valley Historical Society.)

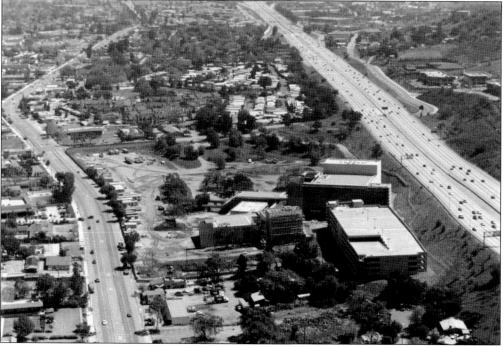

This final view is of the Civic Arts Plaza and Highway 101, facing south. The land of the jungle and all its animals have been replaced with a jungle of people and buildings—and memories. (Courtesy of Stagecoach Inn and Conejo Valley Historical Society.)

DISCOVER THOUSANDS OF LOCAL HISTORY BOOKS FEATURING MILLIONS OF VINTAGE IMAGES

Arcadia Publishing, the leading local history publisher in the United States, is committed to making history accessible and meaningful through publishing books that celebrate and preserve the heritage of America's people and places.

Find more books like this at
www.arcadiapublishing.com

Search for your hometown history, your old stomping grounds, and even your favorite sports team.

Consistent with our mission to preserve history on a local level, this book was printed in South Carolina on American-made paper and manufactured entirely in the United States. Products carrying the accredited Forest Stewardship Council (FSC) label are printed on 100 percent FSC-certified paper.

MADE IN THE USA